THE
**PAUL HAMLYN
LIBRARY**

· ◆ ·

DONATED BY
THE PAUL HAMLYN
FOUNDATION
TO THE
BRITISH MUSEUM

· ◆ ·

opened December 2000

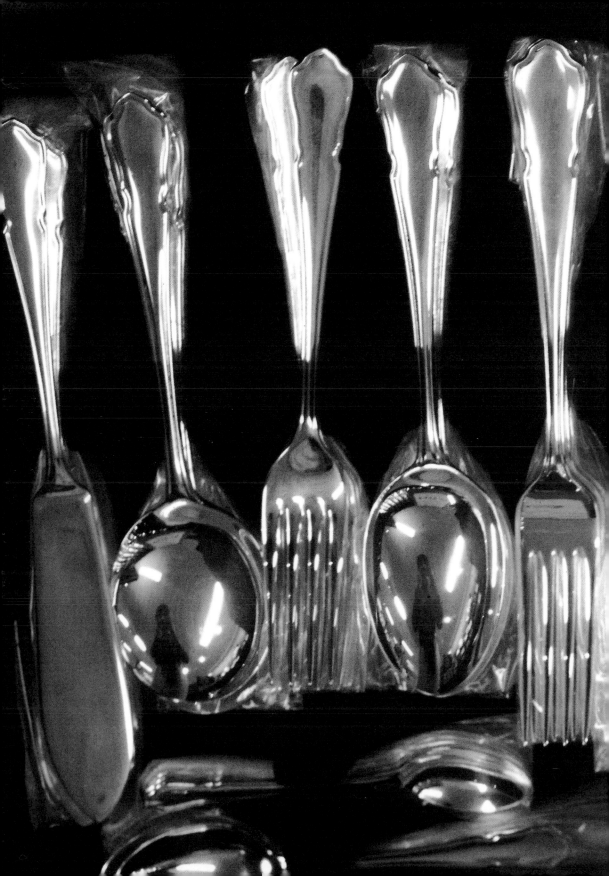

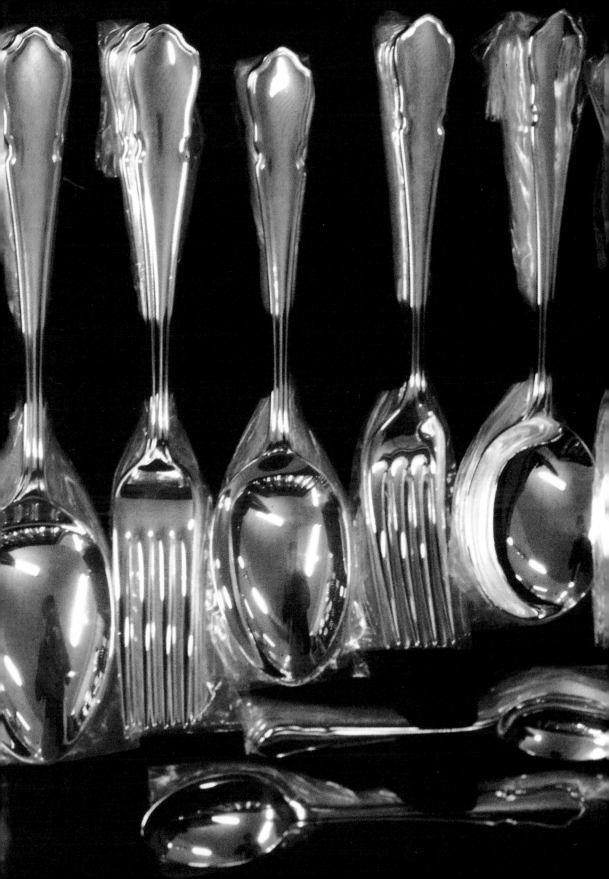

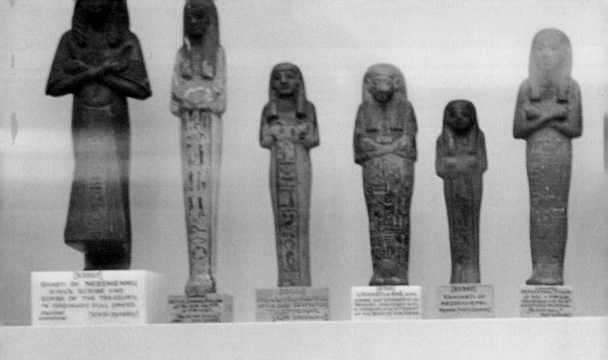

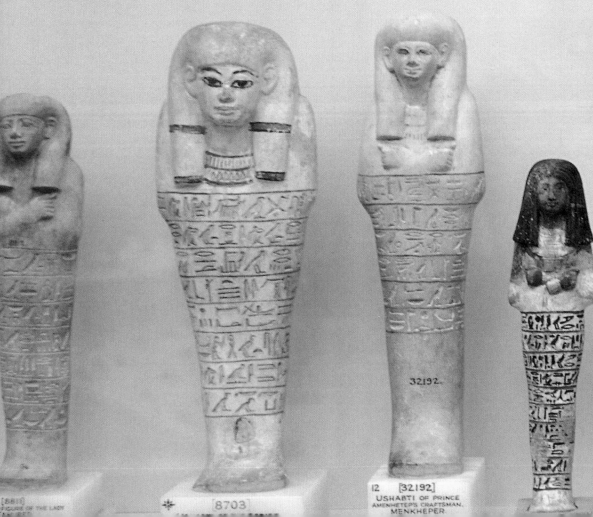

SHABTI OF NESBHENNU,
KING'S SCRIBE AND
SCRIBE OF THE TREASURY,
IN ORDINARY FULL DRESS.

FIGURE OF THE LADY

8703

12 [32192] USHABTI OF PRINCE
AMENHETEP'S CRAFTSMAN,
MENKHEPER.

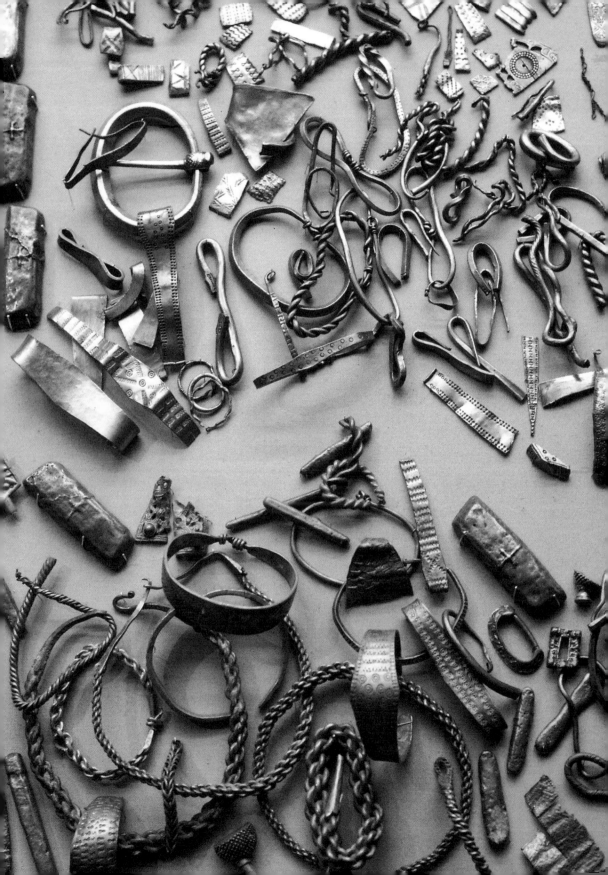

A CIP catalogue record for this book is available from the Library of Congress, Washington DC, USA

Deutsche Bibliothek Cataloguing-in-Publication Data The value of things / Neil Cummings/Marysia Lewandowska. – Basel ; Boston ; Berlin : Birkhäuser, 2000

ISBN 3-7643-6316-9 (Basel...)

© 2000 Birkhäuser – Publishers for Architecture, P.O. Box 133, CH-4010 Basel, Switzerland © 2000 August Media Ltd, 116–120 Golden Lane, London EC1Y 0TL

Texts and images © 2000 the artists

Printed on acid-free paper produced from chlorine-free pulp. TCF ∞

ISBN 3-7643-6316-9

9 8 7 6 5 4 3 2 1

Art director: Stephen Coates Project editor: Ally Ireson Publishing director: Nick Barley

Production co-ordinated by: Uwe Kraus GmbH Printed in Italy

Publisher's acknowledgements: Ann Barrett, Fiona Bradley, Lise Connellan, Diana Eggenschwiler, Jonathan Heaf, Elke Leinwand, Suzanne Müller, Anne Odling-Smee, Elisabeth Scheder-Bieschin, Robert Steiger, Alex Stetter

Authors' acknowledgements: Many people have contributed to this project over the five years of its preparation. We would like to thank them for their ongoing support and encouragement.

We are grateful to both institutions for facilitating the research. In particular, The Trustees of the British Museum, together with Andrew Hamilton, John Reeve, James Putnam, Paul Gardner and Callum Storrie (formerly at BM Design Office).

At Selfridges we would like to acknowledge assistance from Charlie Miller, Nick Cross and the previous Press and Public Relations team with Ruth Barker, Julie Forsyth.

We enjoyed the collaboration with August Media. Ally Ireson,

Nick Barley and Stephen Coates all contributed to a challenging editorial and design process.

Neil: I would like to thank all the Fine Art seminar students at Chelsea College of Art & Design, and the Graphics students at Rhode Island School of Design for letting me try out some of this material, and for their generous responses. I would also like to thank the Research Committee at Chelsea College of Art & Design for their financial support.

Marysia: I would like to thank the Visual Arts Department at Goldsmiths College for their financial contribution in support of my research.

Finally, personal thanks to Jeremy Valentine, Jason Pidd, Eileen Simpson and Basia L.C., who continue to be involved in all our projects; Frank Urbanowski and David Chandler have also offered invaluable advice.

Further information on projects by Neil Cummings and Marysia Lewandowska: www.chanceprojects.com

The Value of Things

Neil Cummings and Marysia Lewandowska

Birkhäuser –
Publishers for Architecture
BASEL · BOSTON · BERLIN

August LONDON

Contents

This book acts as a manifesto for a form of
artistic practice which can take place successfully
outside the realm of the gallery. Neil Cummings
and Marysia Lewandowska have been working
together since 1995, and *The Value of Things*
represents the culmination of a project which
they have pursued throughout the period of their
collaboration to date. Gaining unprecedented
access to the British Museum and to Selfridges
department store in London, the artists have
taken hundreds of photographs inside both
institutions. This visual material, together
with an analysis of the complex mechanisms
of accumulation and display at work within both
organisations, provides the basis for the project.

The Value of Things explores the ways in which the collection and
exchange of objects plays a vital role in our definition of cultural value.
It argues that there is a growing web of links between retail and museum
culture, the nature of which will continue to reflect – and change – the
status of the things we make. An investigation which touches on issues
central to art, consumerism and to design, the book seeks both to
contribute to the understanding of material culture, as well as to bring
together ideas related to commerce and museology often overlooked
by artistic practice.

Cummings' and Lewandowska's work is characterised by the treatment
of analysis and interpretation as an artistic 'product' equal to display
and exhibition. They have worked with a variety of organisations – often
those which possess a large and well-documented collection of artefacts –
including the Victoria & Albert Museum in London, the Musée d'Art et
d'Histoire in Geneva, the Louisiana Museum of Modern Art in Denmark,
and even the London Underground Lost Property Office. Their most
recent collaboration is with Tate Modern and the Bank of England in
London (to be completed in Spring 2001), which explores the parallel
mechanisms employed to ascribe value to art and money respectively.
Many of Cummings' and Lewandowska's projects have resulted in a
publication. Although a part of the creative process usually considered
secondary to the gallery-based exhibition, the artists use publications as

another 'site' for a conceptually-based practice.

Part artists' book, part critical text, *The Value of Things* extends their practice to a new territory, wherein Cummings and Lewandowska accept the challenge of creating a publication which can operate in the context of commercial book publishing. In preparing the book, the artists have employed a highly collaborative approach that is typical of their work. Unusual though this approach to artistic practice may seem, an acceptance of input from outsiders is of course a common feature of gallery-based exhibitions: technicians, film editors, carpenters, curators, writers, architects and graphic designers play an important role in the creation of art and in its display. In fact there are a number of parallels between Cummings' and Lewandowska's approach and that of other contemporary artists. Their investigations infiltrate our systems of looking at things, undermine accepted ideas and ask us to imagine bizarre or unexpected possibilities in everyday objects.

But while their work is firmly located within contemporary art practice, Cummings and Lewandowska cannot resist challenging established strategies: each project undertaken by them is reliant on a parasitic relationship with an institution, with all of the constraints and benefits that such a relationship entails. The projects are always rigorous in their consideration of their context and public, but at the same time, by embracing such institutional frameworks, the artists can engage with audiences and ideas which would be inaccessible to them if they were not prepared to collaborate in such a way. Moreover, their willingness to work within ready-made structures allows Cummings and Lewandowska subtly to subvert them, and to make them simultaneously familiar and strange. The constant slippages from what we understand to what we don't, challenge us to look and think again at everything we take for granted about the culture that envelops us. In a world overflowing with stuff, *The Value of Things* poses important questions for manufacturers and designers, as well as for retailers, curators and consumers.

Nick Barley and Stephen Coates

13

FOREWORD

We recognise that it is no longer helpful to pretend that artists originate
the products they make, or more importantly, that they have control
over the values and meanings attributed to their practice: interpretation
has superseded intention. It is clear that artworks and artists exist in a
larger economy of art; a symbolic economy built from an interrelated
web of curatorship, exhibitions, galleries, museums, places of education,
dealers, collectors, catalogues, books, theorists, critics and so on.
Contemporary artists are links in a chain of influence that manufactures
the possibilities of an artwork, and are no longer its source.

All of the above people – 'the artworld' – are subject to broader cultural
forces; they are nested within an economy represented by employment,
commercial sponsorship or public funding, and by social activities like
shopping, holidays, museum trips, theme park excursions, as well as
cinema and broadcast television. Given the convergence of the symbolic
economy of art with a wider culture of promotion, *The Value of Things*
is our representation of the forces through which we all learn to structure
an exchange of values with one another, and in the knowledge of which
artworks are conjured into being.
Neil Cummings and Marysia Lewandowska

To live in a modern city is to live in an
environment described by an astonishing array of
things. Growing mountains of clothes, tools, gifts,
souvenirs, art, electronic technology and rubbish
are piling up around us. These objects find their
way into every cupboard, display case, shop, home,
gallery, museum, magazine, computer monitor and
landfill site. Surrounded by a complex mesh of
competing 'product narratives' that dispute ownership, contest
interpretation, and disagree on value, these vast accumulations
of objects – from laptop computers to museum exhibits – are
a powerful reflection of the kinds of societies and individuals
we have become. Because of the ability of material things to
speak to us about who we are, there exists a continuous urge
to control, classify and interpret them. In effect, we use objects
as a sophisticated means of making both ourselves and our
world knowable.

Events in the twentieth century that led to this daunting
accumulation of objects unfolded as the endgame of a revolution
which had begun over a hundred years before. The giant engines
of European industrialisation that initiated the material avalanche
which defines the modern age led to the evolution of institutions
devoted to the display of a wealth of new objects. Under mid-
nineteenth century managerial capitalism, a new system of

manufacturing, centred on the continuous process machine, initiated the mass-production of standardised goods. Based on a rigorous principle of unitisation, these machines turned out lines of products with a relentless efficiency. As the amount of goods increased, so did their accessibility to people who didn't belong to the wealthy upper classes, previously the only sector of society that had been able to afford to accumulate large numbers of material possessions.

In Europe, the advent of the railway accelerated the speed at which goods could be moved from ports — or from manufacturing or wholesale sites — to the growing cities for retail distribution. From the 1840s onwards, newly-integrated city transport systems also meant that urban populations were able to mirror the flow of goods. The creation of more elastic infrastructures allowed the emerging suburbs and surrounding countryside to fuse with city centres in a continuous process of exchange. At the same time, the growth of free-trade liberalism meant that the circulation of goods also increased internationally; through a network of buyers and agents, merchants scoured the world for new products, penetrating lines of trade into countries which had previously been resistant to a market economy.

Traditionally, the privileged sector of European culture tended

to value the 'Fine Arts' — painting, sculpture and the souvenirs of the aristocracy (and that of their advisers and dealers, and the galleries, private homes, academies and museums through which they circulated) — as a primary index of taste, education and power. Such a value system privileged history, singularity and academicism, producing a stable symbolic economy grounded in the interpretation of old objects which had been removed from the everyday circulation of things. But as the nineteenth century progressed, the power associated with cultural competence (a sense of participating in the interpretation of material culture) could no longer be restricted in this way.

Able to purchase an extensive range of commodities made available by the new methods of mass production, the rapidly-emerging urban middle class now had the opportunity to set itself apart from the industrialists (who emulated the old aristocracy), and from the more established urban working class. By discriminating in an increasingly precise way amongst the products of industry and commerce via more democratised access to material things, those outside the social élite began to make consumer decisions. For the first time, the middle classes were actively participating in the creation of values, values of all kinds.

Although products began to play an increasingly symbolic role, the expression of their value as part of material culture also

guest towel,

Face cloth,

required a physical machinery of supply and display. *The Value of Things* sets out to explore the development of two institutions at the heart of the system that sources, transports, warehouses, stocks, interprets, displays and redistributes material things. These institutions constitute the most privileged sites within the social organisation of all objects, images, signs and services: the department store and the public museum. *The Value of Things* pictures what it suggests are two archetypal models: Selfridges, the first purpose-built department store in London, and the British Museum, England's earliest public museum, using their specific histories to suggest the significance of similar institutions worldwide.

Although clearly organised around different economic drives, what the store shares with the museum is the encyclopaedic desire to render the whole world understandable: classified and displayed for the visitor to consume. But at first sight this desire doesn't seem to be made manifest in the same way. Department stores hold the promise of a semiotic democracy, played out live amongst the profusion of the present: new lines of goods, new products, new possibilities; whereas in contrast, as museums inherited their collections and core practices from an 'old' aristocracy, their motivation is to protect an image of singularity through collecting souvenirs of the past.

the '100% Cotton Cable Collection' extends twenty metres in every direction as it runs through a broad spectrum of muted colours. Towels merge into bathrobes and

The Value of Things is a collection, but it doesn't follow the current fashion for fetishising a particular object, designer or style; it is not just a display case for yet more things. It explores the fact that the values attributed to objects are not properties of the things themselves, but judgements made through encounters people have with them at specific times and in specific places. To make sense of objects, you must look to a context. By assembling their 'twinned' histories, *The Value of Things* demonstrates that the store and the museum are institutions formed by various complex and often contradictory drives. These forces are so powerful and have existed for such a long time, that they appear to be 'natural' phenomena, to underpin an inevitable order of things. Through narrating the respective stories of the British Museum and Selfridges, they together become a means both to make those forces visible and to trace their effects. It also emerges that the institutions are themselves agents of change, that at a profound level they have always structured – and still structure – our relationships to things.

bedroom wraps, linen gowns slip through accessories and on into co-ordinated bathroom weighing scales... the scales abut the rattan-bound wooden handles of various natural-fibre scrubbing brushes, then an assortment of natural sponges merge into loofahs, and on into hand-made oatmeal and glycerine-rich soaps... wrapped in raw

But *The Value of Things* is far from being simply a history, a task of looking backwards. The book tracks the narratives of the store and the museum through into the newly-diffused cultural territories of the present day. In a digital era, the relationship between objects and value is changing as rapidly as ever and may even be accelerating; the traditional principle of value based on the expression of accumulated excess (vast stores of capital embodied by stockpiles of gold, products, artefacts or art) now has far less relevance in a formidably-connected electronic economy. Instead, value is ever more intensively squeezed from the movement of the digital image of objects and information. Similarly, the

cardboard, the soaps cascade off a suite of Indian-style display tables that visually merge into the muddy swirl of neutral tones: greens, beiges and ochres... linen face cloths, jute body rubs, exfoliating fibre mittens give way to bright plastic containers (confusing at first as they appear at odds with the classificatory system,

department store and the museum are also undergoing a radical transformation – they may even be heading towards a convergence.

As they are superseded by out-of-town shopping complexes, or their convenience challenged by the rapid point-and-click of e-business, stores are being encouraged to reinvent themselves as places in which the ruthless forces of commerce are obscured behind an image of public service and spectacle. Product displays translate into changing 'exhibitions' as everything is cloaked in a subtle nostalgia, repositioning the store as a tourist destination akin to other cultural sites. In turn, as a result of significant shifts in both public subsidy and the nature of visiting audiences, museums are

but then it dawns on me that they are special containers for soaps, toothbrushes, pot-pourri and other bathroom paraphernalia)... and eventually we loop round through fragrances, essences, gels and foams, to luxury towelling bathrobes and back to 'Bathroom Linen'. While I buy the flannel, I may as well get a new bodyscrub.

having to aggressively market and license their collections, histories and buildings as a 'brand'. Museum collections and their parallel information shadow (photographic archives, databases and academic information) are harnessed as potential new revenue streams via tiers of licensed commercial access. As our most unique artefacts are integrated into a wider culture of exhibition, and seamlessly integrated into the retail present, museums are having to compete just as aggressively as department stores to control the flow of value through things.

Museum

Although the modern public museum – a space to
generate and police narratives regarding all objects,
images and information – found its ideal form at the end
of the nineteenth century, the tangled roots of museological
culture reach back much further into history. With its
stock of relics satisfying a public curiosity for tangible,
authenticated objects, the early Church is often cited
as the origin of the drive to accumulate that underpins
museum culture. Throughout the Middle Ages, faithful
pilgrims traversed Europe to glimpse holy bones and
cult objects, in the religous precursor of modern secular
tourism. Abbot Suger in his Inventory from Saint Denis
recorded the spoils from various twelfth-century French
Crusades, including: 'A piece of the true cross, a drop of
Virgin's milk, nails, hair, and foreskin all belonging to
Christ, various stones, a Griffins egg, etc.'[1]

At the heart of the experience of pilgrimage was the
guided tour, during which artefacts and relics were revealed
as part of a sequence of stories and theatrical unveilings told
and performed by a member of the local clergy. Through
this process of narration, people were able to comprehend
an individual object in all its sumptuousness and freakish
wonder, while simultaneously, things were deployed
symbolically in relation to their mutual fulcrum, faith.[2]

The second strand of the story of museum provenance
might track Church collections as they were dispersed
during the sixteenth century into the private ownership of
the European nobility to form *Wunderkammer* or 'Cabinets
of Curiosities' (the German *Kammer*, English closet, Italian
gabinetto and French *cabinet* were all varieties of a small

25

1. See *Abbot Suger: on the Church of St Denis and its Art treasures*, Erwin Panofsky. Princeton University Press, New Jersey 1979
2. Stephen Bann describes the ways in which relics were displayed in a short but illuminating essay, 'Shrines, Curiosities and the Rhetoric of Display' (in *Visual Display: Culture Beyond Appearances*, ed. Lynne Cooke and Peter Wollen. Bay Press, Seattle 1995)

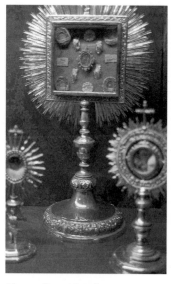

Above: reliquary from the treasury of the Cathedral Coro, Cordoba, Spain

display room or cupboard). Although these collections differed from groups of holy relics in that they didn't manifest a principle of common order – the munificence of God – what they did share with religious collections was their use of objects as status symbols. In tales told by affluent collectors as an embellishment to the act of displaying new finds (narratives describing acquisition and provenance), objects were deployed as elaborate signs for the power of their owner. As the popularity of collecting grew amongst the cultural élite, the drive towards individualising groups of objects accelerated as people began to theme the contents of their cabinets, differentiating theirs from any other. Collections began to evolve crude typologies (recorded in inventories) that developed into written guides to help invited visitors to navigate ever-increasing accumulations of things. Having expanded, many cabinets fused with the gallery or *grande salle* of great houses (previously reserved for the exhibition of paintings) to produce the embryonic display model that was to form the basis of the museum. The published guides to these private displays formed an integral part of the growing fashion among the aristocracy to embark on 'The Grand Tour', a journey taking in the endorsed 'wonders' of Europe and its major collections. In an echo of earlier pilgrimages, these tours became the means to acquire both knowledge and material – souvenirs – for tourists' own collections, established on their return.

The third strand of museum geneaology could be related back to a classical heritage. Greek myth describes the Nine Muses (daughters of Zeus) singing at banquets of the Gods,

26

where in return for milk and honey they inspired the creative citizens of Ancient Greece by revealing the magic of the arts and the mysteries of science. The *mouseion* was the first shrine dedicated to the Muses, eventually becoming a repository for gifts, then a temple for the arts, and finally, a collection of artefacts acting as souvenirs of past glories. Fragmentary evidence to support the idea that these kinds of sacred stores actually existed can be found in the Treasury of the Athenians at Delphi in Greece built in the fifth century BC, or in the reputation of the astonishing collection amassed some two hundred years later by Ptolemy II Philadelphus at Alexandria in Egypt, an immense library supplemented by painted images, sculptures, treasures and the spoils of war. The significance of these collections was that they inaugurated a desire to be encyclopaedic in the original sense of the word: to offer a 'complete circle' of learning, that wasn't matched again until the end of the nineteenth century.

FOUNDATIONS

During the latter half of the seventeenth century in England, Sir Hans Sloane (a distinguished physician) began collecting a miscellany of botanical specimens sourced from trips he made to France and the West Indies. The diarist John Evelyn noted in his entry for the 16th of April 1691:

> 'I went to see Dr Sloane's curiosities, being a universal collection of the natural products of Jamaica, consisting of plants, fruits, corals, minerals, stones, earth, shells, animals and insects, collected with great judgement; several folios of dried plants, and one which had about

In England, John Tradescant's cabinet grew to become Europe's finest natural history collection, with a catalogue, *Musaeum Tradescantianum*, published in 1656. On his death, the collection was bequeathed to Oxford University, forming the basis of what was to evolve into Oxford's famous Ashmolean Museum.

27

3. Quoted in *The British Museum*, J Mordaunt Crook. Penguin, London 1972

eighty, several sorts of ferns, and another of grasses; the Jamaican pepper, in branch, leaves, flower, fruit, etc.' [3] Sloane's zoological specimens were joined by collections of classical, medieval and oriental antiquities as well as coins and medals, drawings and paintings, books, publications and manuscripts. On Sloane's death in 1753 (at the age of 92) the collection, now consisting of some 79,575 objects, was bequeathed to King George II for the nation, in return for the guarantee of an appropriate building and the payment of £20,000 to Sloane's heirs. The King was less than enthusiastic about giving his support, so the decision was passed on to a Parliamentary Committee, which (after some deliberation) funded the acquisition of the collection via a public lottery.

The twenty-three official Trustees (appointed by the King, Parliament and learned societies) who constituted the governing body of what was to become the British Museum were selected from among some of the most influential men in the country. With a board that included the Archbishop of Canterbury, the Speaker of the House of Commons, the First Lord of the Treasury, the Bishop of London, the Lord Chief Justice of England, the Attorney General and the Lord Chancellor, the museum dovetailed into a whole network of institutions of social management. Sloane's founding collection was soon joined by others, and by several famous private libraries already acquired by Parliament, in Montagu House, a decaying mansion located on the same site as the present museum. The new museum welcomed its first visitors on 15 January 1759, with a mandate to 'Encompass the whole span of world culture'.

28

Above: bust of Sir Hans Sloane by John Michael Rysbrack in The King's Library, British Museum 1999

As directed by its founding Act of Parliament, the
British Museum's policy was to reserve its treasures for
'studious and curious persons' only. Fearful that the 'lower
classes' would laugh rudely at natural history exhibits and
disturb the concentration of more learned visitors, the
trustees instituted a vetting system that demanded written
applications for admittance which could take as long as
two months to process. This effectively prohibited access
to the museum to all but those with the very best education.
Restrictions relaxed only very slowly. By 1810, 'strangers',
meaning 'any person of decent appearance', were officially
free to roam the galleries, which meant that around 120
people a day were using the Museum. Nonetheless, opening
hours were restricted to only three weekdays from 10am-
4pm, as a means of ensuring that 'inappropriate persons',
implying anyone who had to work for a living, were denied
entrance. To further protect a 'correct' atmosphere,
supervised tours were also instigated to regulate the
flow of people around the building.

CLASSIFICATION

As the eighteenth century progressed, advances in science
and an increasing confidence in human reason fostered
by the Enlightenment began to dilute the power of theology
in determining systems for 'holding things in place'.
Information could now be forged into knowledge through
an ability to recognise resemblances and discern objective
differences between things. Observation, classification
and inference replaced the tacit order of faith in advancing
learning, and in driving collecting practices. An insistence

29

Guided walks were the cause of some
frustration: a German visitor
commented: 'I am sorry to say that it
was the room, the glass cases, the
shelves... which I saw; not the
collection itself, so rapidly were we
hurried through the departments.'[4]

4. Quoted in *The Story of the
British Museum*, Marjorie
Caygill. British Museum
Press, London 1985

Collecting Collecting is a powerful tactic for making sense out of the
material world, of establishing trails of similarity through
fields of otherwise undifferentiated material. The collection
relies on a related series of technologies: ordered accumulation,
cataloguing, classifying and arranging; devices that allow every object
to be imagined as singular and unique, even though it is plucked from
an endless series of similar things. To collect is to divert an object from

Charles Townley, born in 1737 to a distinguished family, became an enthusiastic collector of antiquities after living in Rome. His first purchase in 1768 was the sculpture of a group of boys fighting over a game of knucklebones. In Townley's time the piece was incorrectly attributed by the art historian Johann Winckelmann to the Greek master Polykleitos, an error that increased its value by £400. After Townley's death in 1805, the collection was acquired for the British Museum by an Act of Parliament.

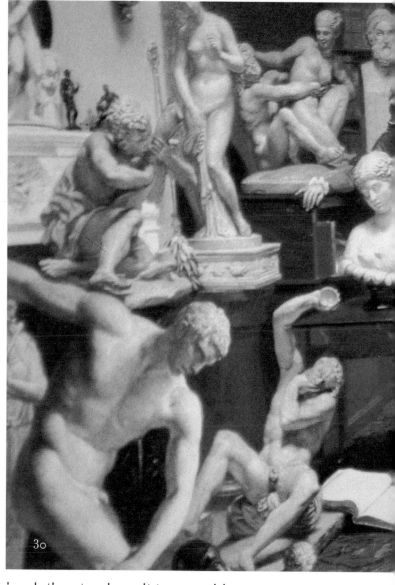

30

any prescribed path or circulation, to place it to one side. It is possible that the obsessive accumulation of serial things can defer the alienation experienced as a result of intensified material consumption. As a peculiar form of accumulation, collecting appears to intensify the relationship between artefacts and collectors, facilitating a mutual exchange of identity. The drive to acquire more things contains, orders and arranges people's desires, creating an

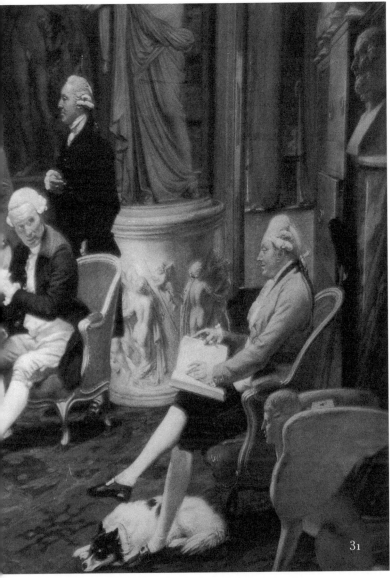

illusion of mastery through delineating a 'knowable' space within the apparently endless universe of materiality. And it is in this way that the collection, no matter how humble or personal, dovetails with the encyclopaedic drives of the museum. To order is to know, to have the ability to recollect and interpret. At whatever scale, collecting is informed by the desire to insure the owner against the inevitability of loss, forgetting and incompletion.

In France between 1751 and 1780, a great multi-volumed encyclopaedia was published under the general editorship of art critic, scholar and playwright, Denis Diderot. Its aim was no less than to 'order and connect all parts of human knowledge'.[5]

In 1753, the Swedish botanist Linnaeus published the results of his *Flora Lepponica*, laying the foundations for a taxonomic system intended to accommodate the diversity of all natural things; and between 1749 and 1767, the first fifteen volumes of what was eventually to be a forty-four volume natural history inventory was produced under the leadership of the French naturalist Compte de Buffon. The 'Initial Discourse on How to Study Natural History', which attacks Linnaeus, is a brilliant examination of classificatory systems.

5. Quoted in *D'Alembert's Preliminary Discourse on the Encyclopaedia*, trans. R N Schwab Bobbs-Merril. New York 1963

on there being a causal relationship between interpretation (understanding) and objects, meant that the gathering and classifying of material evidence granted artifacts sovereign status in the accumulation of information. Furthermore, as the reach of rational science extended, knowledge split into biology, mathematics and history; and then combined and recombined in the disciplines of language, physics and the law, until it almost seemed possible, through learning, to glimpse a comprehensive inventory of the known universe.

This was to be the age of the great encyclopaedia, one marked by the dream of the systematic organisation of all things – and of the museum being the perfect institution to house them. In the late eighteenth century, many collections passed from the ownership of the sovereign to the State, as young nations struggled with new forms of government and democracy; in France, Germany, Italy and Russia, governments seized private assets for redistribution as part of the public wealth. But ironically, these convulsions didn't radically alter the ethos that guided the collections of Europe's fledgling public institutions. The breadth and diversity of the museum display was still used as a glorifying sign of the power and prestige of its owner; it was simply that the sovereign or the aristocrat (figures who had earlier usurped the Church as the locus of power) were now being replaced by the State.

SEQUENCE
In 1776, the Royal Collection in Vienna devolved to the Austrian state. Its paintings were housed in the Belvedere Palace, the former summer residence of Prince Eugène

32

of Savoy, while the bulk of the antiquities, mixed with a miscellany of other objects, was stored in the Hofburg (the winter palace). Two years after the initial move, the curator at the Belvedere, Christian von Mechel, declared his purpose as being 'to use this beautiful building, so suitable by its separate rooms, so that the arrangement should as far as possible be a visible history of art'. The installation of the painting collection was the first to be guided by the principles of the emerging discipline of art history. Paintings were displayed chronologically by national school, or, 'first-to-last' through an artist's life, and hung in clearly labelled, uniform frames. An informative guide book accompanied a walk through the exhibition (perhaps the first moment when this use of the word was appropriate), as von Mechel's galleries broke with the style of the 'jumble of treasure' displays that had characterised earlier collections.

This model of a smooth, linear sequence from classical to contemporary was soon to dominate thinking in the arts. In all areas of cultural life, new knowledge was being made public through the rational and intellectually coherent display of things. It was at this point in history that the democratic order of the modern nation state began to find its image, in material form. At around the same time as Vienna saw the birth of the exhibition as we understand it today, in London, insufficient funding meant that the British Museum was unable to fully pursue its dream of a harmonious 'core' collection, disabling the encyclopaedic drive at its heart. The Act of Parliament which instituted the new museum had officially obliged it to:

'acquire the most magnificent and mundane products

33

It was the first great art historian, Johann Joachim Winckelmann who had laid the foundations for neo-classicism and modern art history, with the publication in Germany in 1764 of *The History of Ancient Art* and, in 1775, *Reflections on the Imitations of the Ancients*. In his writing, Winckelmann departed from the tradition of gossipy reportage[6] and presented the history of art as a chronological progression backwards in time to the perfection of ancient Greece.

6. See for example, Giorgio Vassari's 1568 edition of *Lives of the Artists*

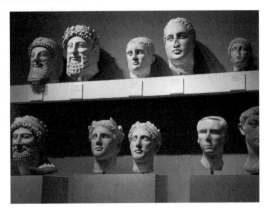

Donations listed in the Museum's *Book of Presents* include: a hornets nest found in Yorkshire (1757), vertebrae and other bones of a monstrous size supposed to be a large sea animal (1758), a stone resembling a petrified loaf (1760), a starved cat and rat (1762), a dried thumb dug up in the foundations of a St James's coffee house (1766), an unburnt brick taken out of the foundations of the supposed Tower of Babylon (1768), and a monstrous pig from Chalfont St Giles (1770).

7. Quoted in *The Story of the British Museum*, Marjorie Caygill. British Museum Press, London 1985

of every society, throughout that society's history. And furthermore, to store these artifacts as evidence to enable successive generations to interpret and reinterpret the past'.[7]

But this was proving to be an impossible task. Even at this early stage in its evolution, precedents were being set which have troubled the Museum ever since. Principal among these was a lack of regular public funding for acquisitions (something that today continues to make the Museum heavily reliant on private donations to extend its collection).

Despite the fact that fulfilling an obligation to be comprehensive didn't look to be an achievable short-term goal, the momentum of general acquisition was nonetheless still increasing. Donations frustrated the Museum's impulse to frame and structure by generating an arbitary stockpile of things: the first Egyptian mummy arrived in 1757, in 1779 Captain Cook returned from a voyage to the South Seas with outstanding artefacts from the Pacific Islands, the Rosetta Stone arrived from Paris in 1802 (part of the spoils of war after the defeat of Napoleon) and in 1804 the Townley collection of Classical sculpture (excavated in Italy) was purchased for £20,000 and displayed in temporary sheds in the garden of Montagu House.

EVOLUTION

Initially, as artefacts joined the Museum's collection, they were divided into 'Natural' and 'Artificial'. But as their volume grew, this rough division soon became unworkable, so in 1807 the Trustees instigated the application of more 'rational' curatorial standards by appointing 'Keepers'

34

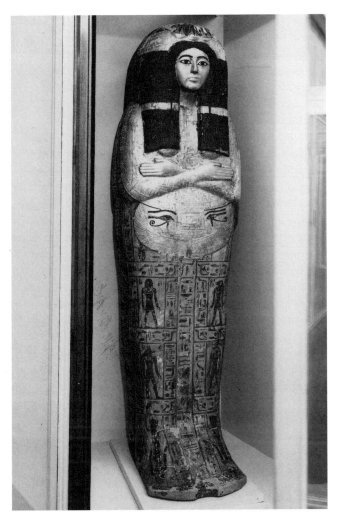

Souvenir

Before the time of the public museum, a privileged and restricted symbolic economy was expressed through the antiquities, paintings or fine art objects circulating amongst a small band of wealthy collectors, advised by educated experts. 'New' objects only entered this economy by being rediscovered through archaeology, or when established families dispersed their collections either by selling them, or bequeathing them in lieu of tax or death

to emerging sub-departments. What resulted was the destruction of many 'curiosities' and the over-indulgence of a contemporary taste for antiquities: the glories of Greece and Rome had caught the imagination of educated Georgian London, particularly the taste of the Museum's aristocratic trustees. To make way for these newly fashionable acquisitions, most of the accumulated anatomical specimens were off-loaded to the Hunterian Museum (soon to become the Royal College of Surgeons Museum), or burnt in the gardens as 'zoological rubbish'. 'Natural' and 'Artificial' soon fractured into 'Printed Books', 'Manuscripts' (including coins and drawings) and 'Natural Productions' and 'Artificial Productions'. Representational shifts within the Museum reflected the increase in information produced by new forms of knowledge, as the legacy of the *Wunderkammer*, that of curiosity and novelty, was slowly tempered by artifacts intended to communicate the idea that things could be divided into types or classes.

In the early years of the nineteenth century, Montagu House began to burst at the seams. In response, in 1804 a major expansion was paid for by a donation of funds from Parliament. The first part of a staggered building programme, the East Wing was built to house the recently donated 70,000-volume King's Library. This extension was completed in four years, but it took a following thirty for the constantly-revised masterplan to be implemented across the rest of the site. During this period, Montagu House was slowly subsumed and eventually replaced, as the building as one might recognise it today began to take shape. Throughout the first half of the nineteenth century and

36

duties. In this context, the expert wielded the power to bestow the label 'authentic' – certifying provenance, age and authorship – and benefited from the resulting effect on objects' desirability and price.

The unstoppable growth in trade and the concomitant increase in the volume of material things during the nineteenth century, meant that control over the definition of authenticity slowly began to slip away from experts and was appropriated by an evolving culture of promotion and

beyond, new excavations and private donations poured artefacts into the expanding Museum – among them the now infamous Elgin Marbles, and the remains of one of the Seven Wonders of the Ancient World, the Mausoleum of Helicarnassus – complementing major royal donations of paintings and coins. During the same period, the Museum's original expansion plans were comprehensively revised. Most of the collection's paintings were moved out of Montagu House in 1824 into the recently founded National Gallery, the growing importance of antiquities spawned its own department, and in 1835 the Department of Prints and Drawings ceded from 'Manuscripts'.

In the 1830s and 1840s, recent finds in geology and palaeontology precipitated thinking that radically reconfigured the history of the planet. Coupled with new material uncovered in the field of archaeology, these discoveries forced scientists to produce a 'deep' model of historical time, one that reached back to a period well beyond the frame used by the western Creation myth narrated in the Bible. This new and provocative 'extended' perspective rendered redundant any interpretations of the diversity of the world as a manifestation of the boundless inventiveness of God. In place of thought inspired by faith, there slowly emerged a rational theory of creation and development based on the principle of the 'natural selection of favourable variations'. Proposed by Charles Darwin, this theory argued for the possibility of systematising natural diversity into a series of developmental chains, the basis of links between natural things that could be traced back through history to uncover shared ancestors and shared

commodity. New retail stores mimicked the museums with their promise to supply everything that could be produced, and as a result many things – in the form of serial reproductions, machine-standard products, casts, copies, replicas, and limited and signed editions – became torn from their context and cast adrift in a sea of other extremely similar artefacts. In an attempt to punctuate the continuous stream of images and objects passing through distributive systems, a nascent advertising

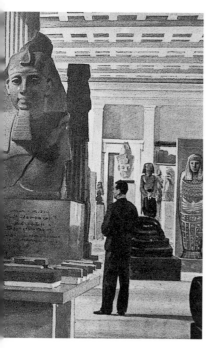

Imagine an unfolding display sequence which starts from ancient ovoid stones, moves through sharpened sticks-as-spears, and ends up with beautifully engineered self-loading Enfield rifles.

origins. Twenty years of Darwin's research culminated in the publication in 1859 of *The Origin of Species*. A revolutionary challenge to all that had come before, the book helped formulate a smooth evolutionary model for the natural world which narrated the development from ancient primitive organism to modern European human along a single, apparently uniform line. The shock of such abrasive thinking in the natural sciences triggered a wave of reclassification in the British Museum's zoological collection, resulting in a new interpretative structure centred on an ordered, 'evolutionary' display sequence.

What was less immediately obvious was the way in which evolutionary theory influenced the display and interpretation of more explicitly 'cultural' objects in the Museum and, specifically, how artefacts from 'other' cultures were catalogued and exhibited. Technology and its history became associated with European expansionist 'free' trading plans that were themselves informed by beliefs about moral, economic and civil progress. Echoing the new methods of classification and display applied to the Museum's zoological stock, links between made objects – ranging from utilitarian to decorative – could now be forged on the basis of a wide range of similarities: function, colour, regional distribution, form, provenance, maker or estimated age. And through these kinds of interpretative choices, it was possible to configure objects in ways that supported a simplistic narrative which tracked the development of a primitive 'Other' into the contemporary perfection of the advanced European. Interpretative narratives based on Darwin's 'favourable variations' theory

38

media deployed the idea of the authentic as a temporary marker, a co-ordinate (stripped of any absolute value accrued through circulation in a restricted economy) around which arbitrary values could flicker and then dissolve. In a seemingly homogenised mass of consumables, nothing has a verifiable 'essence' or a legitimate 'history'. Born into a promotional media, things can be made the puppets of any number of narratives of origin and belonging.

The Pitt Rivers Museum in Oxford is perhaps the best surviving example of an evolutionary schema. Despite the appearance of charming chaos, each artefact on the mezzanine floor is allotted a definite place in the –White, European – development of things.

were used to support an unsubtle and racist history of humanity, mirroring Britain and other nations' confident colonising grip on large parts of the world. Against this background, museums everywhere began to reorganise their collections, as schemes using a neo-classical taxonomy inspired by prior generations' fetishism of ancient Greek culture (a fashion which itself had replaced 'jumble-of-treasures' displays) gave way to the ordering of things in evolutionary series.

ANTIQUITIES

Although the British Museum was constantly acquiring and expanding, even in the early 1830s there were still virtually no British antiquities in its collection. This imbalance was the legacy of the Museum's early emphasis on acquiring classical objects, a policy that had attempted to strengthen the nation's imagined connection with the ancient Mediterranean world, based on the notion that Britain's acquisition and interpretation of its material remnants also made it the rightful heir to a classical heritage. However, a small but vociferous pressure group made up of individuals from both inside and outside the Museum began to agitate for the investigation of a more localised history. Their efforts were rewarded in 1866 by the formation of the Department of British and Medieval Antiquities, which both classified and interpreted recently-found 'lost' objects as new archaeological sites around the country began to supply artefacts to overcome the perceived lack of indigenous items. This shift in curatorial priorities culminated in 1880, when the Museum's natural history specimens (including

As more funds became available, the British Museum expanded further: the remains of Montagu House were demolished in 1845, making way for a new entrance and the spectacular neo-classical façade which was unveiled in 1852. The famous single-domed Reading Room was completed in 1857.

Under these conditions, mass-consumed objects become souvenirs for origins they could never have. The souvenir (a quality wrapped around an object rather than the object itself) allows any thing to narrow the perceived gap or lack between an experience and its recollection. In this distance resides a terrible yearning, a yearning to locate points of origin, trace lines of inheritance, and authenticate experience. Essentially, the souvenir articulates the drives that

underlie the desire to construct a material image of oneself — to order thought and feeling by finding their equivalence in material things. The notion of the structured or systematic acquisition of collectables suffused with the souvenir's nostalgia might perfectly describe what informs the practice of the public museums, as well as the motivation to secure a personal reminder

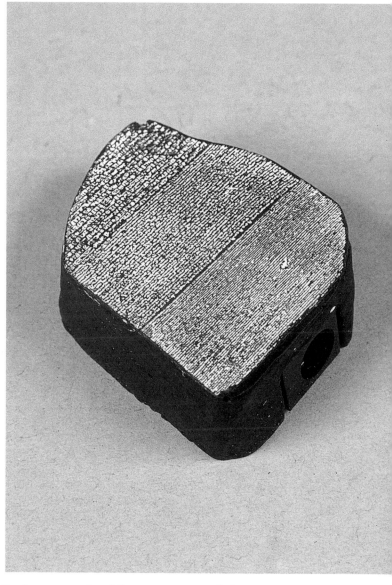

(the Rosetta Stone pencil sharpener) of the museum visit.

 Museums are institutions that hold a sequence of redundant historical artifacts, held in conserved perfection to support the fantasy of origins we need to anchor us as we drift amongst the multiple choices of an intensely-commodified present. These sequences routinely place eoliths (crude hand-held ovoids of flint from the Pleistocene age) at the start of the technological alphabet.[8] As a church only becomes truly sacred

following the introduction of a relic, so contemporary material culture – the endless succession of brushes, ultra-brite cleaners, cars, portable tie presses and moisturisers – uses the 'dawn stones' as an imaginative beginning to locate and authorise the entire series. If the material present appears to be a field of transient, confusing, contradictory and discontinuous values, we are able to

EOLITH

4¹

8. See *Man the Toolmaker*, Kenneth P Oakley. British Museum Press, London 1975

9. See *On Longing: Narratives of the Miniature, the Gigantic, the Souvenir and the Collection*, Susan Stewart. Duke University Press, Durham, North Carolina 1993

negotiate a relationship to it by constructing a (collective and individual) past that is always profound, deep, continuous and stable. Although all objects exist in the present, first and foremost, museum artefacts refer back into a historical past. As the souvenir, from the eolith to the pencil sharpener, gives memory a form, the museum's referent is always consistent: the desire for authenticity.[9]

mineralogical, geological, botanical and zoological
materials) were moved out of the main Museum building
and into related institutions in South Kensington.

INTERPRETATION
Towards the middle of the nineteenth century, there
was mounting pressure for the Museum to become
more democratic both in terms of its access policy and
interpretative approach. A House of Commons Select
Committee Report on Arts and Manufacturers had already
begun to precipitate this mood in 1835, when in its
recommendations to Parliament it stated that, in order
to promote the production of better-quality goods, 'the
opening of new public galleries for the people, should as
much as possible, be encouraged'. The belief was that

Pitt Rivers In 1886, four years before his death, Lieutenant-General
Pitt Rivers offered his collection — more than 10,000
items amassed over twenty years — to the University of
Oxford, which built an annexe to the existing museum to house them.
In 1904, the second curator of the museum, Henry Balfour, delivered
a speech outlining a possible methodology and theoretical model
for collection and display:

exhibiting an exemplary vase or display sequence could educate public taste, and so affect people's ability to discern and then purchase (and so create a demand for) more 'appropriate' – more refined – objects. This sense of shifting prerogatives was reinforced further in 1837 by the opening of the Museum for the first time on a public holiday. Previously, prohibitive admission times had ignored the needs of working people, making the collections available only to a limited group made up of scholars, wealthy tourists and those on private incomes; but this new directive enabled 23,895 people – many of whom were from classes well outside the social élite – to pour through the galleries in a single day. Ironically, after this unprecedented gesture had been made, there followed a stream of complaints. Some first-time visitors voiced resentments about the collection: about the lack of contextual information, its classification systems and individual exhibits. As a new audience for the objects in the Museum's galleries, those who had previously been excluded didn't have the educational vocabulary to comprehend the significance of what they were looking at.

Despite these problems, the 1835 report did set in motion forces which were to form the basis of a newly egalitarian approach to cultural access. It also produced the will to found the National Art Training Schools (the basis for institutions such as the Royal College of Art) and, in part, triggered the staggering accumulation of objects and people that constituted 1851's 'Great Exhibition of the Works of Industry of all Nations'. As the nineteenth century progressed, the idea of the museum as a cultural institution

43

'[...] as a collector he [Pitt Rivers] was somewhat omnivorous, since every artefact and product fell strictly within his range of enquiry. His collection, nevertheless, differed from the great number of private ethnographic collections, and even public ones of that day, inasmuch as it was built up systematically with a definite object in view. Suffice it to say that, in classifying his ethnographic material he adopted a principal system of groups into which objects of like form or function from all

became firmly embedded in the public consciousness, operating as both a metaphor for, and a means of making manifest, the variety of the constantly-expanding material world. The findings of the Select Committee Report had confirmed an attitude which had already gained support amongst the Museum's Trustees and their friends in Parliament, one that treated the collection as a resource for public education; as a positive tool for a richer, more civic cultural life.

Political pressure had also begun to be exerted on the Trustees from the middle classes via letters to the newspapers. As a growing potential audience, they demanded interpretative practices more sympathetic to those without the intellectual privileges of an élite education; whilst in Europe, invigorated liberal and democratic governments were also recommending museum access for all sections of the populace. Ironically, the growing dominance of this democratic mood acted to deform the founding ideals of the British Museum. A tension emerged between the Museum's new governmental mandate to use its collection to both civilise and inform a cohesive public, and its established role as an institution charged to narrate an encyclopaedic collection using an approach prohibitive to all but the most educated visitors.

EXHIBITION
In response to pressure from both the government and the public, in the 1860s there was a discernible shift in the way the Museum's collection was exhibited. Each displayed artefact was now isolated from its neighbour for extra

44

over the world were associated to form series, each of which illustrated as completely as possible the varieties under which a given art, industry, or appliance occurred. Within these main groups objects belonging to the same region were usually associated together in local sub-groups. And wherever amongst the implements or other objects exhibited in a given series, there seemed to be suggested a sequence of ideas, shedding light upon the probable stages in the evolution of

As a result of the Great Exhibition, the British Museum's attendance figure for 1851 was an impressive 2,527,216.

American zoologist G Brown Goode's definition of a well-arranged museum was 'a collection of instructive labels illustrated by well selected specimens.'[10]

legibility, balanced against a suitably 'neutral' background, installed in a vitrine with good natural light, and accompanied by descriptive labelling (usually listing its title, provenance and/or date of manufacture, and brief contextual information). As a result, the physical layout of the Museum began to resemble that of a book, with main chapters, sub-headings, paragraphs, particular sentences and individual words; each artefact was subsumed in a larger – evolutionary – narrative structure. It was at this moment in its history that the Museum sutured together all the newly-evolving academic disciplines into a coherent whole.

By exhibiting artefacts in a manner calculated to embody and communicate specific cultural values – narratives of progress and evolution – this collection environment enabled a direct flow of knowledge, via the medium of display, from artefact to visitor. This means of understanding was reinforced by the physical architecture of the Museum, which with its grid-like structure of parallel galleries and cross-connecting rooms imposed a specific itinerary for the visitor to follow. A walk past sequences of ordered objects, following a prescribed route through the main galleries and smaller adjacent spaces, enabled the visitor to trace the key narrative at the museum's heart: the evolution of Western European culture. In this imagined 'total classificatory system', it became increasingly difficult for an object to exist as a thing of wonder. The expansion of rational knowledge supplanted the singular, novel object of curiosity – the object capable of stopping you in your tracks – with things deployed to illustrate a particular class or type of object. The logic of this scheme was that even a

10. Quoted from Goode's *Principles of Museum Administration*, published in 1895

this particular class, these objects were especially brought into juxtaposition. This special grouping to illustrate sequence was particularly applied to objects from the same region as being, from their local relationships, calculated better to illustrate an actual continuity. As far as possible the seemingly more primitive and generalised forms – those simple types [...] whose use is associated with primitive ideas – were placed at the beginning of each series, and

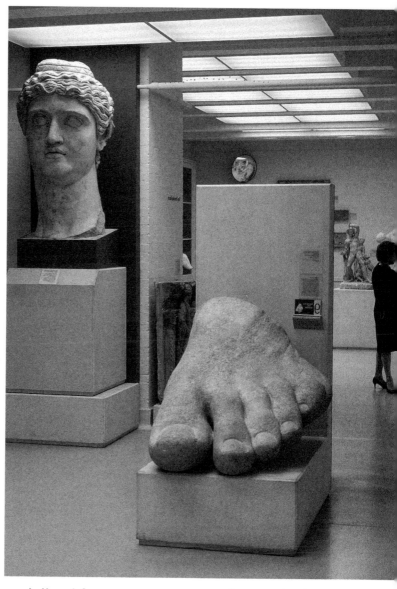

11. Quoted in *The Journal
of the Anthropological Institute*
(in *Museum Journal* Vol. 3,
June 1904); and in *Memoirs
of General Pitt Rivers*, Harold
St George Gray. Pitt Rivers
Museum, Oxford 1905.

the more complex and specialised forms were arranged towards the
end. The primary object of this method of classification by series was to
demonstrate either actually or hypothetically, the origin, development,
and continuity of the material arts, and to illustrate the variations
whereby the more complex forms belonging to the higher conditions of
culture have been evolved by successive slight improvements from the
simple, rudimentary, and generalised forms of a primitive culture.'[11]

'masterpiece' had precedents, and inevitable links to similar artefacts (copies or reproductions). Objects were no longer able to rupture the schematic order of things.

Once acquired by the Museum collection, artefacts ceased to have any practical application. Torn from the system of exchange, from the varied, circulating life of things – the preordained role of any object can easily be eroded by contact with day-to-day living (a cracked teacup becomes a home for bits of jewellery, a cricket bat turns into a doorstop) – objects succumbed to any number of aesthetic or academic narratives; most often, narratives locating ideas of origin and authenticity. The Museum policed the boundaries of the representation of things, desperately guarding against spontaneity or spillage by imposing policies guided by an obsession with sequence and order, description and label. Everything was put in its chronological place. The gap between this authoritative, fixed order and the extraordinary richness with which people interact with things opened a divide between visitor and artefact, as all the variety engendered by the performance of exchange disappeared. The Museum seemed cursed by the convention of its exhibitionary practice: to exist in the present but to belong to the past.

ACADEMIC
As it moved towards the twentieth century, the British Museum was driven to develop more accessible, clear and informative displays to engage its public. At the same time, the Museum's scholars withdrew from the more speculative public exhibition of knowledge, and retreated into work that

47

It was German scholar Theodore Adorno who first teased out the play between museum and mausoleum: to display an artefact, it must first be stripped from the context which confers its meaning; unable to be represented in use, the artefact is 'dead'.[12]

12. See 'Valery Proust Museum', Theodore W Adorno. Quoted in *On the Museums Ruin*, Douglas Crimp and Louise Lawler. MIT, Cambridge, Mass. 1993

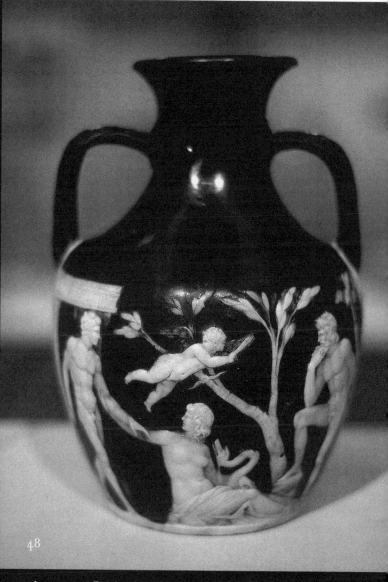

Cameo

The most famous vessel from antiquity, the cameo-glass Portland Vase, was made in Rome, perhaps in the first century AD. Little is known about its early history; the vase first appears on record as belonging to the collection of Cardinal del Monte in 1601, remaining in Italy until Sir William Hamilton, British Ambassador in Naples, purchased it in 1778. Two years later – then back in England – Sir William sold the vase to the Dowager Duchess of Portland, whose name it carried from that moment on. Her son, the Third Duke of Portland, lent the vase to the ceramicist Josiah Wedgwood in 1786, who saw an opportunity to advertise the potential of factory-produced industrial ceramics by copying the renowned piece; proving that new technologies were as capable of producing compelling objects as the revered craftsmen of classical antiquity. The Wedgwood reproductions – technical masterpieces of a black jasper body with an overlaid relief in white – greatly increased the fame of the Portland Vase by distributing its

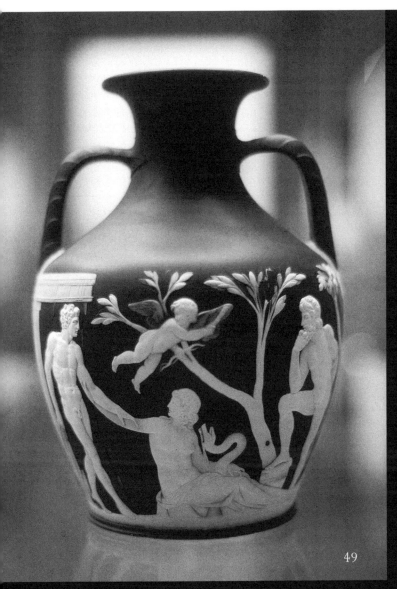

49

image through the influential upper middle class, while at the same time the copies themselves became things of wonder.

Wedgwood's son gave a version to the British Museum in 1802, but it was another eight years before the Fourth Duke of Portland deposited the original. In this instance, the copy preceded the model into the museum collection. While on exhibition in 1845, the vase was smashed into two hundred pieces by vandals. Ironically, its destruction only further augmented its reputation. The vase was slowly re-assembled and has been restored at regular intervals since. Knowledge gained by the repairs has increased speculation that the vase was already damaged when Hamilton acquired it. Its base was probably longer and conical, containing another layer of (now lost) reliefs which might explain the endless disagreements over the narrative sense of the remaining frieze. It seems that the base of the vase had broken off in antiquity, and been cleverly replaced by a flat bottom. The Portland Vase remained on loan to the Museum until it was purchased from the Seventh Duke in 1945.

Display technologies inevitably override more specific political histories of appropriation and colonial influence. Although the British Museum is sensitive to the myriad campaigns for the repatriation of artefacts to indigenous peoples the world over, it manages to counter them with the idea that the Museum is an international institution, 'a storehouse for the world's treasures'; and secondly, an ethical policy of acquisition is evidenced by the claim that the British Museum has never collected material which has left the country of origin illegally.

focused on factual detail, description and cataloguing. This academic specialisation produced a massive archive of documentary material (matching a broader cultural shift towards bureaucratic forms), and caused a major fracture within the institution as the growing demands of academia-as-civil-service clashed with the Museum's mandate to demonstrate its interpretative practices to a wider public. With some unease, parts of the collection were divided out for study series as, often on the grounds of their fragility, artefacts were removed from public exhibition.

From this moment onwards, the Museum's exhibitions ceased to act as the evidence of state-sponsored research, as academic texts replaced the artefact as a means of advancing and supporting knowledge. Driven by the complex and patient assembly of textual information (measurement, classification and description), research and its objects became hidden from public view. As if to compensate for the doubts this triggered – any process of narration away from the gaze of the visitor can raise questions as to why particular stories are constructed – the Museum shifted away from the struggle for clarity in representation to the use of an increasingly authoritarian tone, perhaps masking the confusion of academics as they were faced with the increasing complexity of the material world.

50

The Great Exhibition
of 1851 triggered radical
changes in the display
of things. Mass-produced
objects and museum
artefacts were given equal
status in a feast of public
entertainment

During the early nineteenth century, various trade associations in the heartland of English manufacturing held exhibitions modelled on the French Industrial Exposition of 1789. They were intended through competition to encourage the design and production of things, and to give visible public expression to the expanding 'world of goods'. These exhibitions reached their zenith in England in 1851, with the spectacular accumulation of things that was 'The Great Exhibition of the Works of Industry of all Nations'. The driving force behind the exhibition was Henry Cole, a commissioner for the Society of Arts, which since 1846 had organised annual product displays intended to educate consumer taste. Cole was able to mobilise the support of Prince Albert (then President of the Society) to help form a Royal Commission to co-ordinate the planning and promotion of the exhibition. When reporting to the Commission, Cole was enthusiastic about its scope:

> 'A great people will invite all civilized nations to a festival, to bring into comparison the works of human skill. The organisation of this giant enterprise; the inclusion of every type of process of manufacture; the successful appeal to all

classes of the population; the stimulation of trade, will commend this Exhibition to our ancestors, as it now does to ourselves."[13]

13. Quoted in *The Great Exhibition of 1851, a Commemorative Album* (produced by the Victoria & Albert Museum). HMSO, London 1950

Ideologically, the Great Exhibition acted as a break point in both the narrative of museum history, and in the wider economies of material culture, presenting an opportunity for the new 'Products of Industry' to merge with art and entertainment in a previously unimaginable new leisure space. Joseph Paxton's extraordinary design for a building to house the exhibition – known colloquially as the 'Crystal Palace' – used mass-produced cast iron components to support a glazed roof over an exhibition space spanning nineteen acres, criss-crossed with two miles of display aisles. Located in Hyde Park (at the time, a fashionable London surburb), the festival managed to attract some six million visitors – a third of the combined population of England and Wales – to marvel at the products of 13,937 exhibitors.

In 1852, as a direct consequence of the Great Exhibition, the Government founded (under the Board of Trade) the Department of Practical Art, which was to oversee education, and the founding of a new museum. 'The Museum of Manufacturers', now known as the Victoria & Albert, was founded on the profit – £186,000 – from the Great Exhibition, and the nucleus of the collection purchased from its finest exhibits. Its motto was 'By the Gains of Industry, we promote Art.' *Victoria & Albert Museum Guide.* HMSO, London 1956

Contemporary products took on the appearance of museum exhibits as

art objects vied for attention with the latest industrial technology. Excitement and spectacle played their part in dissolving the traditional hierarchies that structured relationships between things, as artefacts merged in the unifying medium of entertainment. A souvenir catalogue describes a walk through the galleries and lists the objects one could have encountered:

> 'tropical plants and trees, fountains, statuary, an American organ, the Indian Court, Africa, Canada, the West Indies, the Cape of Good Hope, the Great Furniture Court, Sheffield and its hardware, shawls, flax and linen, a Medieval Court, brass and ironwork, leather, fur and hair; woollen, silk and lace power-looms in motion; marine engines, hydraulic presses and steam hammers...'[14]

14. The inventory continues over the following three, densely-typeset pages. From *The Art Journal Illustrated Catalogue – a souvenir of the Great Exhibition of the Industry of All Nations 1851*. The Proprietors, London 1851
15. Donald Preziosi in *The Optic of Walter Benjamin*. Black Dog Publishing, London 1999

This stunning material display – 'A brief and blinding flash in mid-century'[15] – lasted a mere six months, yet the Great Exhibition crystallised many of the symbolic systems through which England subsequently learnt to be modern.

To help stunned visitors navigate through the aisles of objects, reconstructed 'villages', historical 'styles'

We occupy this page with works by M. [...] who may be, with justice, considered the most important Austrian manufacturer, [...] be claims high rank, as well for the [...] taste as for the beauty with which his

nova, and other objects of art, which may thus be conveniently and elegantly arranged over their surface. The figures who hold them, the

fanciful foliage, and the equally fanciful group of horned serpents forming the base, are all remarkable for the vigour and delicacy with which

they are carved. The small SETTEE beneath is equally good in execution, but is less graceful in design, and is not redeemed from heaviness. In some instances, parts are better than the whole

of these articles of furniture, and many that might be passed by as ordinary looking, deserve study in detail; we engrave the central portion of a SOFA-BACK as an illustration of this, which

works are executed, will be readily admitted by those who inspect the four palatial apartments he has furnished for the inspection of "the world," in its Exhibition. A very grace-

ful novelty is represented in our first cut; it is an ORNAMENTAL STAND, of a fanciful and original design, the large framed boards of rosewood being intended for the exhibition of small minia-

possesses elegance. The TABLE beneath is intended for a drawing-room; it is of the finest-coloured and most costly wood. The CHAIR is

of sumptuous construction, whether its carved work, or its upholstery, be considered; it is constructed with the strictest attention to comfort.

and themed 'collections' were employed to render exhibits comprehensible. The novel experience of disjunction – a clash of the prosaic and the exotic – was simultaneously heightened and dissolved both by the medium of exhibition and the panoply of Empire. Given form via the museum experience as a ritualised encounter with the past through things, historical memory could now mesh with the full force of the already commodified present. This complex encounter created a new democratic template for the way in which objects could be gauged that would prove to be a defining characteristic of modern urban life. The 1851 Exhibition was the medieval *Wunderkammer* on an industrial scale, an instrument for assessing the equivalence of all values, over all time, through the medium of display. It constituted an intoxicating mix of competition, capital, people and things, of reconstructed history and the fleeting material present that has been replicated in every shopping mall and museum ever since.

The extraordinary success of England's Great Exhibition inspired an irregular series of international celebrations (which nations competed to host) that focused the force of an emerging material culture.

It is not surprising that the most perceptive of late-nineteenth century art critics, Charles Baudelaire, wrote a critical review of one of these exhibitions, the Parisian Exposition Universelle of 1855. The review teased historians and other critics – particularly the neo-classical descendants of the art historian Johann Winckelmann – for their failure to accommodate the enormous variety of artefacts from disparate countries into their 'classical systems of universal beauty':

'There can be few occupations so interesting, so attractive, so full of suprises and revelations for a critic, a dreamer whose mind is given to generalisation as well as to the study of details – or, to put it even better, to the idea of an universal order and hierarchy – as a comparison of the nations and their respective products. [...] I will thus put it to any honest man, always provided that he has thought and travelled a little. Let them imagine a modern Winckelmann (we are full of them, the nation overflows with them; they are the idols of the lazy). What would he say, if faced with the product of China – something weird, strange, distorted in form, intense in colour and sometimes delicate to the point of evanescence? And yet such a thing is a specimen

The engravings on this page are from a suite of carved decorative furniture, consisting of about twenty objects; they are manufactured by Mr. A. J. JONES, of Dublin, from his own designs, which are intended to illustrate Irish history and antiquities; the wood of which they are made is Irish bog-yew. The EASY-CHAIR, or arm-chair, shows at the back busts of ancient Irish warriors, supporting the ancient arms of Ireland; the elbows are represented by wolf-dogs, one in action, the other recumbent. The TEA-POY, being a receptacle for foreign produce, is appropriately ornamented; its base exhibits the chase of the giant deer by wolf-dogs. A sarcophagus WINE-COOLER is elaborately sculptured on the four sides, and enriched with bacchanalian busts at the angles; a figure of Silenus surmounts the top, with the accessories of the welding, harp, &c. The FIRE-SCREEN, one of a pair, stands on a tripod comprised of three lions with imbruted heads; the mounting-glass panel form the field on which is sculptured, in demi-relief, an ancient Irish Kern, or light-armed warrior, on the one, and on the other, the Gallowglass, or heavy-armed Irish warrior.

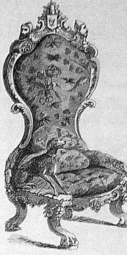

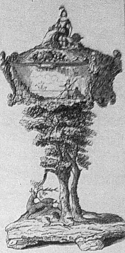

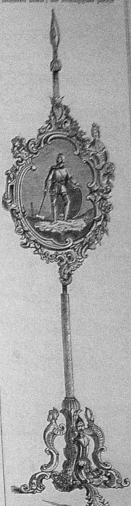

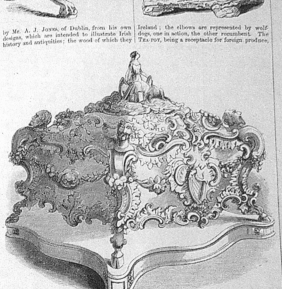

of universal beauty; but in order for it to be understood, it is necessary for the critic, for the spectator, to work a transformation in himself which partakes of the nature of a mystery – it is necessary for him, by means of a phenomenon of the will acting upon the imagination to learn of himself to participate in the surroundings which have given birth to this singular flowering.'[16]

Baudelaire pointed to the fact that the Fine Arts as they were traditionally thought of could no longer, in the face of the vital new products of modern industry, sustain their identity as the pinnacle of culture. Equally importantly, he recognised the lack of a contemporary critical language to map the change. Baudelaire's review broke a tradition of art criticism in side-stepping an aesthetic élite and directly addressing the bourgeoisie, whom he acknowledged (and also despised) as the new public, and hence as a significant force in matters of taste and value. The review also expressed an anxiety common in nineteenth-century metropolitan society: how to discriminate amongst a broad field of undifferentiated artefacts.

16. Quoted in *Charles Baudelaire, Art in Paris 1845-1862*. Phaidon Press, London 1965

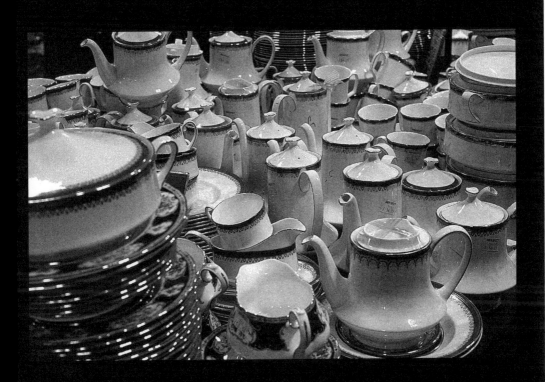

CROCKERY SALE, BASEMENT, SELFRIDGES 1997

Part Two Store

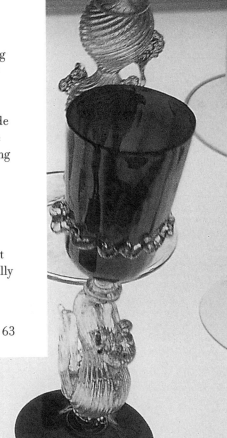

In Europe before the middle of the nineteenth century, cities with a population of more than 100,000 were scarce. The limited nature of public transport, either within or between urban centres, restricted both work and the purchasing of goods to the immediate locale in which people lived. Shopping, whether buying staples or more luxurious items, entailed haggling over prices in dingy specialist shops; and trading space was confined to the front of the ground floor, as shop owners normally lived at the rear of their properties and sub-let any space on upper storeys. Stacked on shelves, goods for sale simultaneously constituted both stock and display; products were only pulled down and prices offered when customers made a specific request for a particular item. Collectively, these small shops covered the spectrum of available goods, being roughly divided into those selling expensive, high-quality goods, or those offering merchandise which was either cheap or low-grade.

The emergence of horse-drawn street cars, in the decade between 1850 and 1860, allowed retail stores in the centre of cities to attract clientele from throughout the burgeoning metropolitan area; as a result, shops began to expand. Rising sales triggered rent increases, so proprietors began to push trading up onto other floors and to put their basement spaces to better use. As trading became more competitive, newly-designed multi-floored stores maximized the relationship between a building's footprint and the volume of selling space. These new stores eventually took trade away from the shopping arcades which had evolved in the second decade of the century. Arcades

63

Writing in the 1930s, theorist Walter Benjamin recognised in the arcades a perfect, miniaturised model of the bourgeois world, as well as the birthplace of modern consumer culture. As a Marxist, Benjamin interpreted the by-then abandoned arcades as signs for the failures of capitalism, as evidence of false trails to be used against propaganda based on a 'rational and evolutionary' view of progress. Benjamin could of course never have foreseen the arcades' nostalgic resurrection by the tourist industry as heritage sites. Examples are the Galeries St Hubert, Brussels (built 1847) and the Royal Arcade, Cardiff (1856).[17]

17. See *The Dialectics of Seeing: Walter Benjamin and the Arcades Project*, Susan Buck-Morss. MIT, Cambridge, Mass. 1989

(essentially small streets covered with iron and glass roofs) housed cafés, luxury stores selling 'white' goods, food shops, apartments, sometimes brothels, and, occasionally, art galleries, bookstores, theatres and news-stands. As the layered stores expanded, they began to mimic the arcades' complexity, and to borrow their novel principle of juxtaposition. It was the conjunction of these two urban phenomena, the miscellaneous arcade and the multi-floored shop, that produced the embryonic form of the department store.

The early French stores are acknowledged to have had the most radical influence on nascent retail culture, pioneering a model of display that made full use of the potential of theatrical spectacle to make the products of industry 'come alive'. The most famous of these was the Bon Marché in Paris. What had in 1852 started life as a draper's shop, soon flourished into a huge retail operation characterised by the development of a continuously-expanding range of merchandise. In 1869, the store's proprietor, Aristide Boucicaut, commissioned the young architect Gustave Eiffel to design a new building grand enough to match his ambitions. With his resulting design, Eiffel instituted a monumental style of retail architecture, creating an environment that demonstrated all the features associated with modern pleasure and luxury. Dancing with light reflected from its luxuriant marble, bronze and brass fittings, the new store invited people to leave cold, wet streets and enter a realm of seemingly effortless spectacle. This seductive show was rigorously stage-managed by the store's innovative design: the structural use of iron and steel

64

65

**Left: Galeries St Hubert,
Brussels
Above: Marshall Field
in Chicago, rebuilt in 1879
by Daniel H Burnhams, is
the finest surviving example
of the 'classic' department
store**

In Paris, the Bon Marché was followed by Au Printemps in 1865, La Samaritaine in 1869, Les Grandes Magasins du Louvre in 1885, and the Galeries Lafayette in 1895. Parallel developments in retail in the United States instituted A T Stewart and Macy's in New York, Marshall Field in Chicago, and Wanamaker's in Philadelphia.

(copied from new spaces commissioned for the Universal Exhibitions) allowed for the creation of a large, open floor space, supported on widely-spaced internal pillars; glazed light wells meant that daylight could penetrate down through the different floors and dramatically highlight displays well below roof level; and galleried mezzanine floors created the impression of 'cascades' of merchandise, as goods spilled out from one space and down into another. The Bon Marché's huge windows also allowed electric light to flood onto the street, dwarfing the dull glow from nearby gas lights. Lifts and escalators, although initially received as wondrous technologies in their own right, quickly became mere machinery for gaining access to other trading floors; and rest rooms, quiet salons, tea rooms and tropical gardens punctured the roar of the retail floors with spaces of calm. The Bon Marché became a model for stores the world over.

Merchants trading out of the new stores were able to avoid having to rely on the traditionally polarised distinctions of conventional retailing. Through grouping similar goods and trading on multiple floors, they were able to offer a range of good-quality items, but with what appeared to be a poor-quality mark up. The resulting increase in sales speeded up the turnover of goods, which then translated into greater purchasing capacity and, in turn, allowed stores to short-circuit the traditional chain of supply made up of wholesaler, salesman and importer by opening direct connections with manufacturers. Products could now be aggressively sought out, rather than just passively distributed. By fusing the otherwise separate functions of wholesaler and retailer – and occasionally that

66

Exchange Although exchange is a fundamental concept for anthropology, its use in cultural analysis has been surprisingly rare. Denoting the circulation of goods and services through societies, exchange is able to express both intense personal feelings and terrifying international power, to incorporate everything from an intimate lovers' gift to the rules of world-wide trade. Exchange is the mechanism by which objects are acquired, classified

of the manufacturer as well – stores were able to ruthlessly pursue the competitive advantage of a lower purchase price.

BARGAIN

As the early stores rapidly evolved, absorbing adjacent retail sites as they grew to encompass more and more lines of goods, the apparent contradiction of the stores offering an ever-increasing variety of products whilst retaining coherent displays was accommodated by a unique organisational form. The melée of goods as found in the traditional bazaar or general store (where diversity existed, but without classification) was supplanted by a branch structure of grouped products. The store's diverse ranges of themed goods were departmentalised: each merchandise line had its own particular location, buyer, departmental head and separate sales team. By classifying their collection of goods in this way, stores were able to respond to seasonal fluctuations in demand by expanding and contracting departments through planned rotation, or react to circumstance: for example, after rain, umbrella ranges could be extended out to fill floorspace near entrances and exits. Similarly, making the visibility of goods more responsive meant that particular products could, when appropriate, be offered through sales and promotions at a lower mark-up: winter coats could have their prices dramatically slashed after the first warm day of spring. This strategy created the impression of unequal exchange: the customer almost felt they were receiving a 'gift' from the store, encouraging a sense of goodwill which enabled them to be more easily seduced into other potential purchases –

and displayed: it is the means via which economies are made visible and, simultaneously, gain an emotional, monetary or material texture.

Exchange is also the means by which values are distributed within a society. Although value is an abstract concept, the slippery nature of terms like 'beautiful', 'delicate', 'expensive' or 'disgusting' can be given form by material things. Unlike colour, weight, texture or, occasionally, function, these qualities are not properties of the things themselves,

In 1868, French novelist Emile Zola began a sequence of novels which he used to build a portrait of France. In *The Ladies' Paradise*, the twentieth and final book in the series, Zola turned his attention to the department store. Published in 1888, the novel maps the psychology of mass consumption, using the embryonic form of the department store for its narrative context.

The book luxuriates in descriptions of the circulation of money, goods and shoppers. Zola is quick to identify the activity of shopping itself as seductive. Mouret, the store's sophisticated owner, is the great seducer and the finest window-dresser in Paris. In both his private and professional life, Mouret arouses and orchestrates 'women's passions', and his store is a 'temple to desire':

'...as she was going through the silk scarves and glove departments, her will weakened once more. There in the diffused light, stood a bright, gaily coloured display which made a delightful effect. The counters, symmetrically arranged, looked like flower beds, transforming the hall into a formal garden, smiling with a range of soft flower tones. Spread out on the wooden counter, falling from overflowing shelves, and in boxes which had been torn open, a harvest of silk scarves displayed the brilliant red of geraniums, the milky white of petunias, the golden yellow of chrysanthemums, the sky blue of verbena; and higher up, entwined on brass stems there was another mass of blossom-fichus strewn about, ribbons unrolled, a dazzling strand extending and twisting around the pillars, and multiplying in the mirrors.'[18]

the value judgement that something is a 'bargain' could spread from on-sale items to infect adjacent items.

The hierarchical structure of the store encouraged competition between each department for increased turnover and profit, and therefore, for prime in-store locations for their merchandise. This atmosphere demanded more of the stock buyers, forcing them to be alert to changes in manufacturing and rivals' product ranges, and to remain receptive to new ideas in merchandising and display. The acceleration and expansion of the merchandising operation of the first stores was mirrored by the increasing sophistication of their administrative apparatus, marked by the evolution of 'parallel' bureaucratic technologies such as accounting, information regulation, and management engineering. These were supported by a dense network of personnel managers, account directors, management services, audit controllers, finance directors and advertising agents, all co-ordinated by a general manager who was himself kept under the watchful eye of the founder. Monitored and manipulated by this system, the circuits of people, things, and the wash of paper receipts and money were forged into unprecedented relationships of exchange in an animated theatre of retail.

This rigorous structural principle, one informed by the growing unitisation of mechanical production, had a major impact on both the function and status of store personnel. The downgrading of employees' work via a constant sub-division of tasks made it possible to employ less well-qualified people, giving staff a more tenuous and exchangeable relationship with the overall system. This

68

but judgements given form through the objects. Exchange — swapping one type of object, labour, money, service, or leisure activity for another more desirable one — is essentially an exchange of values, and it is this swapping activity that temporarily endows the object itself with those same values.

At the heart of reciprocal exchange between people lies the twin drives of desire and sacrifice: one person's desire for an object, and

insecurity was further intensified by the encouragement of a competitive attitude amongst sales staff, and the awareness that anyone thought of as a mediocre seller could be sacked at short notice. Fear of redundancy meant that it was possible for management to instil strict codes of service and behaviour in the sales team, forging them into a disciplined unit who would readily conform to middle-class ideas of respectability. For the store's environment to work effectively, the behaviour of its workers had to match the high expectations of its customers.

BROWSING

The ruthlessly pragmatic spirit of these employment policies was also at work, albeit in a covert form, in the space beyond the counter. Here a range of new systems meticulously worked to create the impression that people were entering an environment that was both seductive and interactive; the shopper was to feel enabled, not manipulated. These systems included those related to free entry, and to product returns. 'Free entry' simply translated into the absence of a 'house detective/walker' or floor manager (traditionally placed at the entrance of a shop to discourage 'undesirables'). This subtle shift in practice encouraged visitors to enter the store with no apparent obligation to buy, helping blur the distinction between two previously separate social performances: between the aesthetic appreciation of things – the museum visit; and the possibility of buying something – shopping. Put together, these performances fused into a new leisure activity: browsing. The innovative policy of returns allowed stores'

69

18. From *The Ladies' Paradise*, Emile Zola (trans. Brian Nelson). Oxford University Press 1995

another's willingess to give up (sacrifice) the object for that desire or its representation (another object or token). In the modern age, this primal rule has been abstracted, as face-to-face barter has been transformed by the complex structures of manufacturing and retailing. Principally however, the demise of barter has been precipitated by money. In contemporary exchange it is through money that we express the intensity of competing desires, and make the interplay of desire

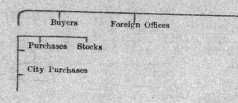

Buyers Foreign Offices

Purchases Stocks

City Purchases

Ins

Stock	Special Orders
Art Needlework	Art Needlework
Baby Linen	Baby Linen
Bathing Gowns	Bathing Gowns
Confectionery	Blouses
Flower Mounting	Coats and Skirts, Gow
Hair Work	Engraving, etc.
Lamp Shades	Hair Work
Made up Lace Goods	Lamp Shades
Made up Ribbon Goods	Mantles
Men's Ready for Wear	Men's Shirts, etc.
Millinery (Trimmed)	Millinery
Perfumery	Nurses' Outfitting
	Optical Goods

Right: 'The Organisation of The Store', in *The Romance of Commerce*, H Gordon Selfridge. The Bodley Head, London 1918

ANAGER OF
NG MERCHANDISE

MANAG
OF SA

Production Department

Selling Records · Publicity

facturing Division · Non-productive Labour · Equipment

─ Department Sales ─ NewspaperAdvertising · Fe

Fitters

Supplies · Machinery · Allotment of space

─ Assistants' Sales ─ Catalogues & Circulars · W

Outworkers · ─ Woven Labels · ─ Spare parts

─ Travellers' Sales ─ Letters · Ou

ns ─ Repairs ─ Glove Cleaning · ─ Stationery · ─ Power

─ Specialised Selling ─ Posters,Hoardings,etc. · In

─ Boots ─ Men's Shirts · ─ Light

─ Exhibitions ─ House Sign Cards · M

─ Clocks ─ Men's Tailoring Bespoke

─ Demonstrations · Fl

s ─ Corsets Stock-keepers · Supervisors · Accounting

El

irts ─ Glove cleaning ─ Staff Records ─ Costing

Fl

─ Hosiery ─ Time keeping ─ Wages

Sc

7) ─ House Flags ─ Cleaning

─ House Linen ─ Mess room Attendants

Gowns ─ Jewellery

for Wear ─ Watches

tting

g

MANAGIN

ER
ES

MANAGER OF
COUNTING HOUSE

M
OF

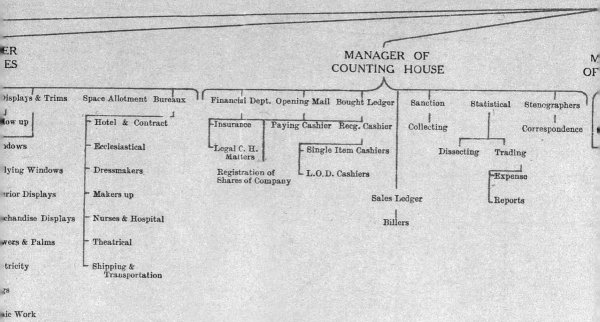

isplays & Trims Space Allotment Bureaux Financial Dept. Opening Mail Bought Ledger Sanction Statistical Stenographers

low up Hotel & Contract Insurance Paying Cashier Recg. Cashier Collecting Correspondence

dows Ecclesiastical Legal C. H. Single Item Cashiers Dissecting Trading

lying Windows Dressmakers Matters

rior Displays Makers up Registration of L.O.D. Cashiers Expense

Shares of Company

chandise Displays Nurses & Hospital Sales Ledger Reports

vers & Palms Theatrical Billers

tricity Shipping &
Transportation

ɟs

ic Work

RECTOR

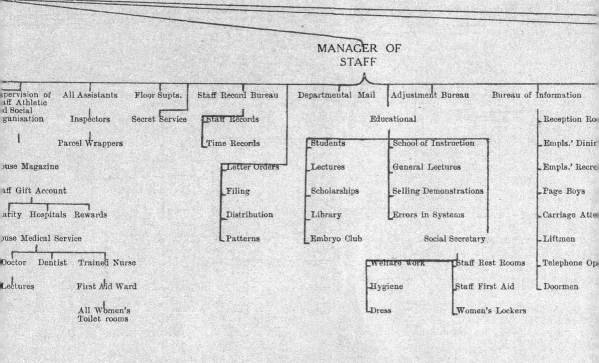

MANAGER OF
STAFF

upervision of aff Athletic d Social ganisation	All Assistants	Floor Supts.	Staff Record Bureau	Departmental Mail	Adjustment Bureau	Bureau of Information
	Inspectors	Secret Service	Staff Records		Educational	Reception Ro
	Parcel Wrappers		Time Records	Students	School of Instruction	Empls.' Dinin
ouse Magazine			Letter Orders	Lectures	General Lectures	Empls.' Recre
aff Gift Account			Filing	Scholarships	Selling Demonstrations	Page Boys
arity Hospitals Rewards			Distribution	Library	Errors in Systems	Carriage Atte
ouse Medical Service			Patterns	Embryo Club	Social Secretary	Liftmen
Doctor Dentist Trained Nurse					Welfare work Staff Rest Rooms	Telephone Op
Lectures	First Aid Ward				Hygiene Staff First Aid	Doormen
	All Women's Toilet rooms				Dress Women's Lockers	

MANAGER OF
SYSTEMS

Paymaster	Timekeeper	City Dispatch	Stable	Receiving	Returned Goods	P.A.C. Desks	Buyer of Supplies	House Cleanir
Staff Bank State Insurance		Country Dispatch	Drivers	Warehouses	Lost and Found	Goods Collectors	Buyer of Books and Stationery	Outdoor Clea
oms		Foreign Dispatch	Stablemen	Transportation	Check Rooms	Packers	Buyer of Catalogues and Printed Folders	Indoor Cleani
Rooms		Special Service	Motor Garage		Approbation Outwards			Window Clea
ts		Mail Dispatch	Motor Drivers					
rs		Post Office	Motor Repairs					

MANAGER OF
BUILDING & EQUIPMENT

...ne ...ents	House Fire Brigade	Electricity		Machinery		Alterations Repairs Cleaning	
...e ...rd		Motor Maintenance	Light	Power	Water Supply	House Carpenters	Fire Inspectors
		Lifts and Lift Machinery		Heat	Plumbing	House Painters	Aero Fire Alarm System
		Synchronome Clock System		Ventilation	Sprinkler System	Fixture Polishers	Fixture & Fitting Repairs
						Upholsterers	

'She carried on talking, saying how convenient the 'return' system was; previously, she never used to buy anything, whereas now she occasionally yielded to temptation. In fact, she returned four articles out of five, and was beginning to be known in all the departments for the strange dealings which were suspected to lie behind the constant dissatisfaction which made her bring articles back one by one, after having kept them for several days.'[19]

19. From *The Ladies' Paradise*, Emile Zola (trans. Brian Nelson). Oxford University Press 1995

customers to take goods home, try them on, possibly even match them with an existing decor, colour, season or wardrobe, or to gather opinions from friends, relatives or husbands. If anything at all discouraged commitment, if the products failed to fulfil the fantasy triggered in-store, then they could be returned without penalty, or swapped for something else.

These systems certainly helped democratise the appreciation of things, but it was the notion of the fixed price which was perhaps the most influential technological reform in the retail economy of the time. The establishment of both marked and fixed prices eradicated the time-consuming necessity of customer and seller having to haggle over every item. It also allowed shoppers to budget easily and to buy with confidence, which radically speeded up the purchase and flow of goods and, in turn, encouraged the store to add a comparatively small mark-up on the unit price of most products. This smaller gross margin was compensated for by higher sales volume and a more rapid turnover in stock, enabling stores to break the rule that suppliers set the unit cost of goods, and to dictate what they were willing to pay their manufacturers or importers. Fixed prices totally reconfigured the circuit of consumption. From this moment onwards, rather than being pushed forwards by technological change, production gained momentum from the newly-enfranchised consumer. It was no longer society's ability to create endless amounts of goods, but its endless capacity to desire them, that now provided the impetus for how and why things were made.

By supplying goods and restructuring and streamlining

and sacrifice visible, as price becomes a representative of what we are prepared to sacrifice for the things we desire.

Modern exchange is not materialistic. It is not objects that people really desire, but their lush coating of images and dreams that mesh with a wider promotional culture fuelled by advertising and the broadcast media. Exchange helps to animate objects with value, and in doing so it weaves a dense social web of aspiration characterised

their distribution, the new stores became the main context, outside the home, in which people were able to experience things. Transforming the mundane activity of buying staples into an increasingly pleasurable experience – one akin to leisure – the stores dissolved any lingering distinctions between need and want. In their newly-commodified form, there were few real differences between products of the same type. Floating free from any notion of necessity, objects were no longer anchored by their ability to fulfil an identifiable need; instead, they became tokens in the games of desire played by an increasingly sophisticated young advertising media.

ATTRACTION

By the 1860s, America was experiencing an accelerated replay of the European metropolitan expansion of some seventy years before. Chicago was the location for a particularly explosive form of this growth, with a population that (starting in 1840) increased from 30,000 to over one million inhabitants in just forty years – making it the sixth largest city in the world.

In 1868, a wholesale dry-goods store, Marshall Field (bearing the name of its founder), opened in the city. Because of the predominantly sparse rural distribution of the settlers, as with other mid-Western stores, business was mainly derived from mail-order and wholesale redistribution. But this tradition was forcibly changed in 1879 by the arrival at Marshall Field of Harry Gordon Selfridge, who at the age of just 21 had quickly grasped the economic potential of responding to the exodus of people

by a cycle of desire, use and disillusionment. Disillusionment inevitably follows exchange; it is never the object which is consumed – instead, it is the relationship between us and the object of our desire. Any nagging

78

sense of frustration prompted by these serial, but temporary fixations
is subtly diffused by the machinery of the promotional media, which
soon helps us supplant disappointment with another desire — one that
is in turn itself eventually extinguished and replaced.

The longing that haunts exchange grows from our inability to
satiate our desires: we are unable to invest in one thing for any length
of time before the object inevitably slides from favour. This process

79

turns every belonging into a souvenir, a reminder of a momentary coherence; it builds collections out of products that have been bought, are no longer wanted and which need to be stored, producing an exhibition in every home. As our experience of exchange intensifies, anything (a cup, a house, a rosebush) is experienced in a subtle relationship to other extremely similar objects. To help structure the products that make up modern material culture, a blend of

It was Mary Douglas and Baron Isherwood who popularised the idea of consumption – in its broadest sense – as a social practice which balances necessity or needs (hunger, thirst, warmth, etc.) within a communicative structure. They recognised that people invest in things they don't need, can't afford, and don't understand. Essentially, the meanings and values, the powerful desires that exchange articulates, overrides any social 'logic'.[20]

from country to city. He convinced Marshall Field's owner to restructure the store's trading priorities, concentrating on retail and supplying the demands of the new metropolitan populace. Selfridge implemented annual sales, clearing stock to make way for the arrival of goods for increasingly frequent 'new' retail seasons. He also removed the store's long counters and their intimidating salesmen, replacing them with tables (particularly on the ground floor) on which things could be displayed in piles. The resultant slipping and spilling of products was a calculated ploy to encourage female customers to touch and interact with the merchandise. To increase the sense of theatre, Selfridge doubled the number of electric bulbs to brightly illuminate displays, and installed a suave 'greeter' at the main entrance, especially to welcome the women of Chicago's burgeoning middle class.

In April 1890, the American President, Benjamin Harrison signed a Bill to:
'provide for the Celebration of the 400th anniversary of the Discovery of America by Christopher Columbus, by holding an International Exhibition of Arts, Industries and the Products of the Soil, Mine and Sea, in the city of Chicago in Illinois.'

Still seen by many as merely an upstart meat-packing town (one founded on the arbitrary advantage of being located at the meeting point of the trans-American railways), Chicago snatched the honour of hosting the Columbian Exposition from other, more established cities. A stunning development was planned for the tracts of sandy clay on Lake Michigan's south shore, with marble palaces and

20. See *World of Goods*, Mary Douglas and Baron Isherwood. Basic Books, New York 1979

similarity and (ostensible) difference has emerged. Many people are familiar with the fine distinctions drawn between series of Impressionist paintings, ancient 'Roman' heads or signed first editions, but modern exchange also encourages us to perceive difference among the limitless expanse of mass-produced goods from lipsticks to bathroom cleaners.

weirdly exotic carnival streets. The latest leg in a global relay that had started some forty years earlier with the Great Exhibition in London, the Chicago expo promised the most spectacular material display the modern world had seen to date. Selfridge immediately saw an opportunity to capitalise. He wanted the fair's hundreds of thousands of expected visitors to be tempted into Marshall Field, to marvel, buy, and then travel home singing its praises. But to become an 'attraction', the store would have to compete with many other impressive exhibition elements, including a 265 feet-high ferris wheel, a marble Agricultural Hall, a wooded island on an artificial lake, gems from Russia, a 10-tonne cheese from Canada, watches from Nuremberg, French Gobelin tapestries, and food and drink offered by German, Irish, Algerian, Tunisian, Chinese and Japanese 'villages'.

Selfridge instructed his stock buyers to travel to points all over the globe to source the most spectacular goods. They returned with silks from Lyon, lace from Nottingham, carpets from the looms of Kashmir, prayer rugs from Mecca, Persian travelling chests, camel bags from the Arabian desert, magnificent gems, handmade English furniture, exquisite Parisian fashions, Native American shawls, silks from the Orient, filmy laces from Belgium, sheer French hosiery, Irish linens, and glass from Bohemia. The store was overhauled to form a fitting frame for this tide of impressive exotica: new ladies' rest rooms were installed, twenty-three elevators added, twelve entrances fitted with revolving doors, and the 100 departments staffed to capacity with a total of over 3,000 employees – it was the perfect moment for Selfridge, who was maturing into a consummate retail

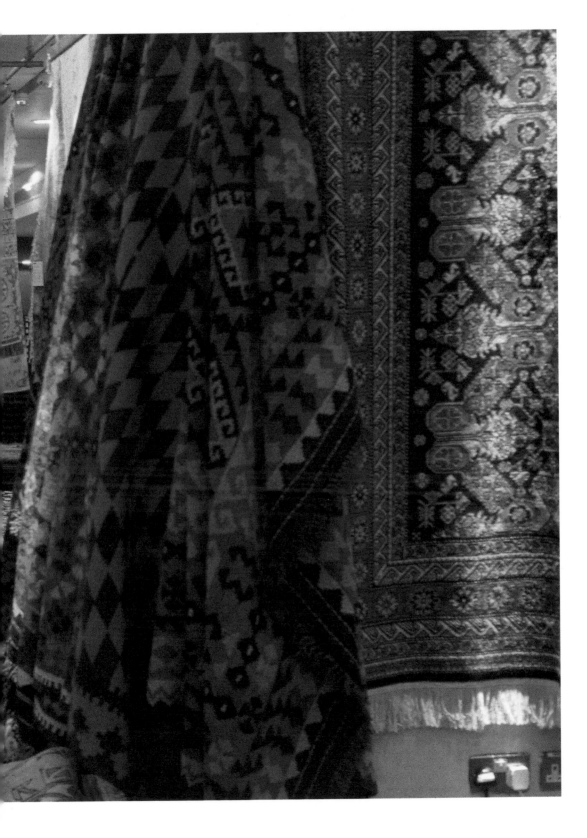

showman. Marshall Field's tie-in with the World's
Columbian Exhibition was a huge success, and represented
the consolidation of a range of promotional practices
department stores had been evolving since their inception.
They had been quick to recognise the potential to
accumulate capital through the extension of the notion of
service, as well as through the propagation of their image
beyond their buildings.

The novel element in what Selfridge achieved with
Marshall Field and the Columbian Exhibition was the
multiplication of the store's promotional connection
with ready-made cultural events. Precedents had already
been set for this back in 1889, when a travelling exhibition
of furniture, paintings and fabrics both designed and
commissioned by British designer William Morris, arrived
in Chicago. Glowingly reviewed by local newspapers,
the exhibition and its objects consumed the city's wealthy
upper-middle class. Selfridge immediately responded by
opening a lavish room display and an exhibition gallery
furnished exclusively with Morris's products. The success
of the gallery resulted in the introduction of a sequence of
changing temporary exhibitions, which were soon followed
by the installation of luxury facilities such as an opticians,
a repair service for jewellery, a cleaning service for clothes
and a tearoom on the third floor.

SENSATION
In 1904, after twenty-five years at Marshall Field, Gordon
Selfridge announced his desire to quit the store. Initially,
he bought an ailing competitor, Schlesinger & Mayer, and

84

traded in competition with his previous employer, but after three months, either unable or unwilling to compete with Field for custom, Selfridge decided to sell up. At the age of 50, he left Chicago for London, intent on founding a dazzling new store in the heart of sleepy English retail. Selfridge experienced enormous difficulties in raising the required capital to fund his vision, as London's complex agreements on property use slowed acquisition of a site, and it took time for building plans to be approved. But finally, in 1907, ground was broken on Oxford Street, strategically close to Bond Street underground station. The site was to form the basis of what was to be Europe's largest retail building. Initially, Selfridges grew in fits and starts, but it soon began to eat its way into an adjacent block of intersecting streets. All of London's previous department stores had shared the root of the Parisian Bon Marché, developing out of conglomerations of smaller shops, but Selfridges was the first department store imagined on such a scale which was purpose-built.

When the first phase of the proposed building was completed in 1909, Selfridges was made up of eight floors (three of them basements), six acres of retail floor space, the longest neo-classical façade of any commercial building, two plunging atriums, a roof garden, nine passenger lifts, the first private telephone, a library and 'Silence' room, a First Aid ward, a Bureau de Change, a ticket booking office, a post office and a bank. With the building and core departments in place, Selfridge recognised the necessity of creating an 'event' to pierce the public consciousness. With this in mind, he persuaded Edward Goldsman, the

Singular and Serial

Any mass-produced object can be given the appearance of singularity, yet nothing is ever truly singular. Singularity exists only at the level of an idea. Few people are fooled by the claims made for everyday objects – 'only-surviving', 'original flavour', 'the oldest', 'modern classic' – but even the 'uniqueness' of the treasures of the museum is something that can be dissolved with reference to a seamless line of precedents. Nevertheless, the attraction

of singularity is part of our desire for every artefact, hence the endless flow of claims for 'original recipe', 'authentic flavour", 'limited edition', 'white label' and 'director's cut'. Deployed and willingly sustained in the advertising media, this perception – that every thing is unique – infects every object, and every collection. Even museum artefacts, promoted by acquisition indexes, collection catalogues, text labels, postcards

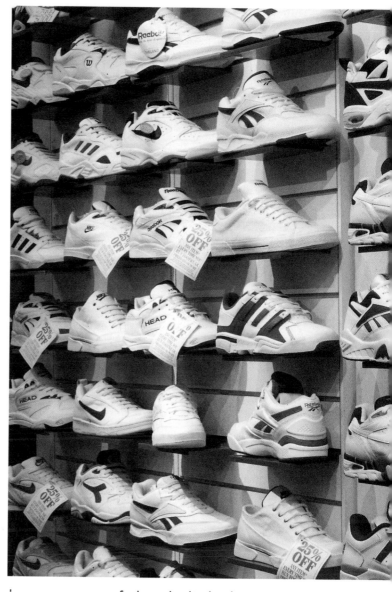

and reproductions, are given a veneer of singularity in the struggle to reconstruct their lost origins, or represent their difference from one another. It is the creation of the idea of the singular, the 'original' in a vast field of almost identical objects, that reflects our own drive to feel individual and special, to be 'one of a kind'. Ownership of an object offers us fleeting happiness at the moment of connection with something we perceive as unique.

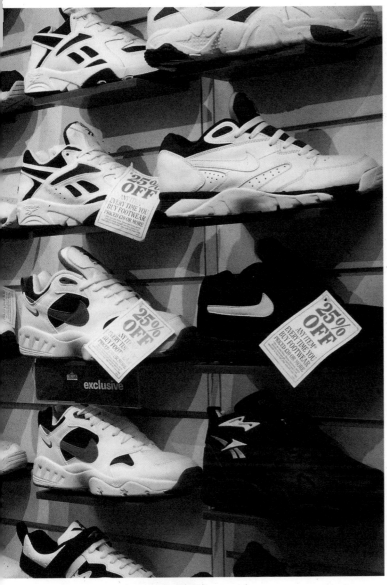

If the museum's principal function is to store the idea of singularity, the department store celebrates the spectacle of abundance, and the series. But the received logic of opposing the singular (as the supposed expression of a true value) with the series (representing the diluted and cheapened essence of a value), becomes increasingly unworkable. Paradoxically, the singular object is a generic thing, an ideal model, assembled from the minute and relative differences in the entire series, collection or set.

Historically, numerous reproductive processes – casts, electrotypes and photographs – were put to use in copying works from the British Museum's collection. By 1837, casts had been made from some of the Elgin and Townley Marbles to distribute to other museums and art academies. Today, the replication of objects from the Museum's collection is handled by its Facsimile Service, which was privatised in 1991.

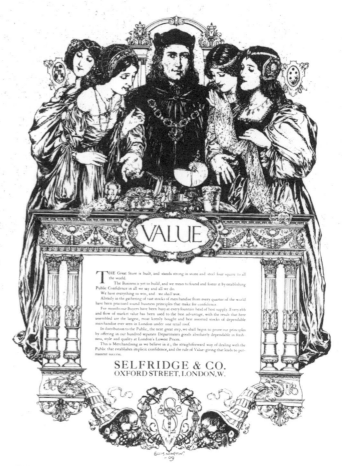

Value by Ellis Martin was one of the full-page advertisements published during Selfridges' opening week. It appeared on Wednesday 17 March 1909 in the *Daily Mail*, the *Chronicle*, the *Paris Mail* and the *Pall Mall Gazette*.

head window-dresser at Marshall Field, to join him in
London. Goldsman planned dramatic windows (and
'rhymed' internal merchandise displays) in which new
fashion items appeared in settings inspired by the paintings
of Fragonard, deliberately chosen to chime with the
contemporary popular taste for reproductions of frivolous
French paintings. The same degree of aesthetic attention
was applied to the store's interior: carpets, wallpaper,
wrapping paper, lift staff uniforms, delivery vans, and even
the letterheads for receipts were all carefully co-ordinated
in Selfridges' signature olive green.

Selfridge & Company opened to the public on the 15th
of March 1909. On the first day of trading alone, 90,000
people visited the store, and the total for the first week
was over a million visitors. Such public enthusiasm was
no doubt fired by the unprecedented advertising campaign
that accompanied the launch, which extended across a
broad sweep of publishing media. Despite the initial flurry
of curiosity following the store's spectacular inauguration,
business began to slow in the first few months of trading,
and the number of customers began to dwindle. In June,
the first sale (of underwear) began, an acknowledgement
that the store needed to be more active if it was to attract
consistent levels of custom; this change of mood also
initiated a stream of price-cutting attractions supported by
daily newspaper adverts. What Selfridge desperately needed
was something to hook the imagination of the wider public.

An opportunity presented itself that summer. On 25 July,
a French aviator, Louis Blériot, flew the first 'heavier-than-
air' monoplane across the English Channel from Calais to

Seduction Through their internal display technologies and use of popular advertising media, nineteenth-century department stores promoted themselves as vast pleasure machines. The stores themselves, as well as the goods, shoppers and sales staff, were all coated with the appearance of leisure and luxury, under the umbrella of desire. Consequently, from their inception, these particular shops were surrounded by scandal, as men's confusion over the public appearance

of unaccompanied (hence 'unowned' and available) women led to endless speculation as to the status of both the store's shoppers and its sales staff. Were they also for sale? Rumours of prostitution were propagated by contemporary novels, and echoed tabloid newspaper reports of 'public' women working as casual staff or drifting amongst the aisles of goods. Stores became known as venues for illicit meetings between mistresses and lovers disguised as shoppers. On his arrival in London from Chicago,

Schooled by his experiences in
Chicago, Gordon Selfridge recognised
the growing power and influence of the
popular press; even before the store
opened, he had hosted a lunch for the
proprietors of all the English daily
newspapers.

Dover, winning the £1,000 prize offered by the *Daily Mail*
newspaper for achieving what had loomed large in the
popular imagination as an almost impossible feat. Selfridge
drove to Dover, hired the plane, and arranged to have it
transported to London the same night, to be displayed in-
store the following morning. The exhibition was a sensation.
Thousands of people queued to see it, related pictures and
headlines dominated every front page, and carefully-placed
advertising filled the morning's newpapers with the tag line:
'Calais–Dover–Selfridges'. Special viewings were arranged
for the House of Commons and House of Lords, and, on
the last day, the store remained open until midnight to
accommodate the 40,000-plus people who had queued
for a last glimpse of the 'headless bird'. With this event,
Selfridge initiated a marketing strategy that linked his
store to all manner of wider promotional phenomena, thus
shaking off the organisational insularity which dominated
conventional British retail.

FANTASY
Understanding the importance of maintaining the
impetus of store merchandising after the commercial
coup of the Blériot plane, Edward Goldsman capitalised
on the excitement it had generated by initiating a series
of frequently-changing window displays installed along the
length of the shop's huge street frontage. These beautifully-
themed presentations of goods created an unprecedented
form of display, a kind of pavement theatre, that offered a
potently seductive contrast to the crammed and overstocked
windows of London's other stores. Traditional window

94

Gordon Selfridge styled himself
as the great seducer, convincing
potential backers that women
would be intoxicated by his policies:
'A satisfied customer means that
I have imposed my will upon her.
She will talk and spread the good

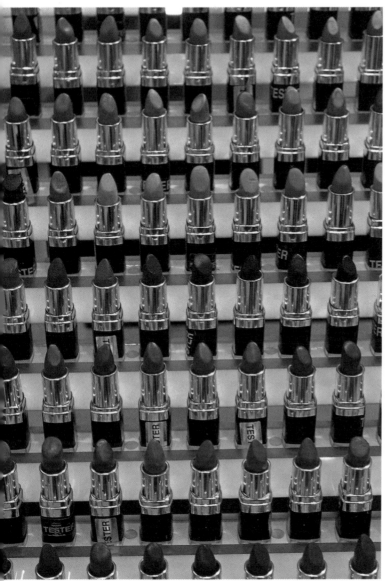

Gordon Selfridge created an early form of advertorial with articles attributed to 'Callisthenes', the first of which appeared in an English daily newspaper on 25 January 1912. Entitled 'On the Joy of Learning' and subtitled 'Selfridges & Co Ltd', it began with the introduction: 'This Column is occupied every day by an article reflecting the policies, principles, and opinions of this House of Business upon various points of public interest'. The text – Selfridge himself wrote much of the copy – read like that of a standard newspaper feature, with only the by-line hinting at its sponsorship and motives. Explicitly promotional articles had appeared sporadically since the opening of the store in 1909, but this new kind of feature inaugurated a sustained commitment to buying space in various daily newspapers. Over the next thirty years, some 10,000 accredited articles were published, the short essays seamlessly adopting the form and tone of the editorials of the newspapers in which they appeared. There was little crude promotion of particular goods or prices. In their place were slightly stilted meditations on the nature of business and commerce, with discreet references linking the main discussion to Selfridges. These articles were amazingly sophisticated promotional tools, with the plain speech of description dissolved by the pleasurable language of seduction.

21. Quoted in *Selfridges*, Gordon Honeycombe. Selfridges, London 1984

news, from person to person, more effectively than any advertisement.'[21]

The female shopper or sales assistant were the figures in which the two principal economies of the store – the erotic and the monetary – meshed. Of course, this applied differently according to social status. Middle-class ladies who used the store enjoyed the comforts of feeling welcome, pampered and served; it was the working-class shop girls who were subject to strict codes of employment and the predatory gaze of

spaces were merely treated as contexts – as vitrines – in which to show goods for sale, with price-ticketed goods crammed into the available space in huge jumbled piles. At night, internal curtains were quietly drawn to signify the sleeping shop, obscuring anything on display. Significantly, Selfridges broke with the principle of a visible closing time, by leaving window lighting on long after the store shut – the image of the store was thus projected out onto the pavements, penetrating the darkness.

A favourite structural device employed in Selfridges' displays was to make the windows explicitly sequential through the use of subtle changes of colour, function, materials or products. As passers-by walked their length, the windows functioned something like film stills, each one an individual 'frame' awaiting the animating force of the shopper to join them together in an impressionistic sequence – one capable of opening up new imaginative spaces in which, by subtle association, people could construct all manner of fantasies. As a result, such displays sparked the development of an entirely new urban activity: window-shopping. Exhibition-style displays of goods were also an effective means of attracting the crowds; the Christmas windows at Selfridges quickly became a tourist staple. Encouraged by his success with the Blériot plane, Selfridge continued to install exhibitions of new technology, through special 'How's It Made?' displays. Over time, various tableaux explained to an eager public the manufacturing processes involved in the production of golf balls, silk stockings, reading glasses, X-ray machines, lead soldiers, artists' brushes, straw hats and a vacuum ice-

both managerial staff and male shoppers. The undifferentiated look of browsing, a disinterested scanning of things, could easily slip into the concentrated look of desire: 'I want that'. Men's decreasing power to regulate the behaviour of women, both politically and economically, seems unconsciously to have projected itself into a fear of uncontainable female sexuality. Nineteenth-century literature introduces the twin themes of kleptomania and rampant hedonism – ascribed almost exclusively to

machine. The impetus of these promotions was extended by spectacular decorations to mark the Coronation of George Vth in June 1911, light shows celebrating the solar eclipse in April 1912, and the premier of the Tango on Selfridges' roof in 1913. By the power of association, the wonder generated by these 'marvels' extended out to coat the products they featured or sought to promote. In the hope of triggering participation – and purchases – the store used these elaborate merchandising spectacles to construct, inform and excite through acts of looking at things.

Marcel Duchamp perceptively called window shopping 'coitus through the glass'.[22]

97

22. See *The Essential Writings of Marcel Duchamp*, ed. Michel Sanouillet and Elmer Peterson. Thames & Hudson, London 1975

women – as evidence of uncontrollable desires, of women running wild. Stores suffused goods and the practice of buying with eroticism; shopping intensified the excitement of delaying possession, introducing a delicious indecision about which item to choose from stunning ranges of similar products. This notion of pleasurable delay provided a focus for men's anxiety about the tendency of middle-class women to simply 'help themselves', to follow their compulsions.

The First World War
ended the first great period
of material expansion.
The museum and the store
would face revolutionary
changes in the production
of culture

On the cusp of conflict in 1913, capitalism had developed into a dense free-flow of goods, money and people – and it appeared to have the entire liberal world at its disposal. But the continuous expansion of material life throughout the 'long nineteenth century'[23] was about to be halted by Europe's first industrial war. A historical period made by and for the middle class would be terminated.

23. A phrase used by Eric Hobsbawm in *The Age of Empire 1875–1914* (Weidenfeld & Nicholson, London 1994) to suggest that the ideology of the nineteenth century survived well beyond the turning of the calendar

The First World War trailed in its wake a terrible crisis of confidence. In the most developed economies of Europe and North America, trade and retail distribution had long surpassed manufacturing as a means of value creation; things were invariably made elsewhere. But in Britain, formerly the most ardent supporter of liberal trade, retail and financial services slumped and, in response, the Government ringfenced the economy in an attempt to boost internal products and markets. Other economies followed Britain's policy, causing free trade – formerly the engine of European expansion – to collapse, as national tarifs and trade barriers began to restrict the movement of things. It would take decades for the flows of capital, people and things to recover their former volumes; and

GREEK SCULPTURE *C*.700—500 BC

Europe would never be able to resuscitate the unbridled optimism it had enjoyed during the first modern period of material culture.

Following the onset of hostilities, the British Museum's immediate plans for continuing its expansion were shelved, Government purchase funding was diverted into armament production, and foreign excavations ceased. The British Government closed all public museums in 1916 and, when air raids became a threat in 1917, some of the British Museum's treasures were transferred underground into central London's Holborn tube station. This period of suspension (the museum reopened in 1919) was not just a pause, it constituted an important punctuation. The ideal of the museum as a perfect vehicle for the public exhibition of the rational expansion of knowledge through things, would now, along with much else, lie buried amongst the ruins of war.

Although it had been piecemeal, the growth of the British Museum up to this point in history had nonetheless spawned a huge, pyramidal organisation: the Museum's Director oversaw departmental 'Keepers' who themselves commanded large, hierarchically-arranged groups of curators and

academics. These patrician civil service employment practices contributed to an exercise of power that was both haphazard and seemingly unaccountable. This organisational principle chimed with the political climate outside the Museum, which was characterised by the approach of Europe's Government-led command economies. As the Continent limped out of conflict, they collectively legislated a shift away from 'free' trade to a more closely policed system of exchange.

But although in its bureaucracy the Museum mirrored the State-sponsored tenor of national life, it had lost the ability to connect with society at large through the represention of knowledge for a broad audience. Both as an academic or public institution, the Museum was simply no longer relevant in the same way that it had been during the closing years of the previous century. The struggle to interpret the world had now shifted from being based on discerning patterns in the past — tradition — to being based on the manipulation of the new products of a commodified present.

Despite the fact that the priorities of the museum-visiting public had changed, the British Museum carried on regardless with established practices of collecting, classifying and interpreting objects; but without the will

or, perhaps more importantly, the Government funding, to make its activities germane to a modern audience. Museum staff were caught up in an arcane world of academia and the authority of 'behind-the-scenes' scholarship, while the public façade of the institution began to look increasingly dull, employing uninspiring and patronising display practices. At one time a radical new technology for organising knowledge through things, the museum had become a drain on the public purse. It began to look like an institution whose moment of civil service had passed.

Between 1914 and 1918, Gordon Selfridge managed to insulate his ambitions for the store against the exigencies of wartime by implementing a range of cheerfully 'altruistic' schemes to retain Selfridges' place in the public consciousness. Many of its window spaces displayed huge maps charting the progress of various military campaigns, and in-store charitable sales generated donations of blankets and cash that were sent out to sites of conflict. But remaining financially viable became more of a challenge as the war progressed; goods shortages, struggling distribution systems and a lack of male workers drove prices up steeply. Money was also in short supply, and the

Government began to promote hoarding and thrift by rationing the exchange of things through the use of coupons. Selfridges responded with 'Private Scrap Goes to War', an exhibition mounted to emphasise the importance of saving domestic materials like paper and rags.

Through skilfully mixing support for the war effort with more explicitly commercial retail promotions –

A SOUVENIR OF PEACE

Gordon Selfridge was always careful to keep advertised prices below the Government's Board of Trade recommendations – the Store continued to scrape a profit. Retailing was no longer to be seen as a celebration of luxurious expenditure but, through advertising, presented as a patriotic service. Offering cash prizes to those who bought war bonds in-store, Selfridges' promotional campaigns raised £3.5 million, enabling Gordon Selfridge ostentatiously to mail a £1 million cheque to the Exchequer. The perpetual present of the store seemed well-equipped to absorb the paradox of continuing to generate money, whilst encouraging thrift, and a duty to hoard and endure.

By 1918, it appeared that one of the few benefits of four years of international crisis had been the explosion of old social orders based on the deference and servitude of the many to the few. The First World War ushered in the possibility of implementing a more widespread participation in culture. As art and science-related certainties engendered in the nineteenth century began to disintegrate, the consensus about what culture consisted of (about which practices, learning, and types of participation were necessarily 'cultural') became increasingly linked to an expanding consumer culture. While the British Museum and other similar institutions were becoming ossified under the weight of bureaucracy, culture – participation in the acquisition and display of things – gained both a democratic veneer and a new sense of urgency.

Although the department store was quickly assuming a greater importance in the creation of cultural value, the entrepreneurial energy which had achieved this position was forcing important changes. As with other businesses, the stores were still

Gordon Selfridge, who had always been astute in cultivating power and influence through links with the popular print media, was quick to recognise the potential of the new broadcast media. At the end of 1923, the British Broadcasting Company (now the BBC) was allowed to install two 150 feet-high radio masts on Selfridges' roof; and in April 1925, John Logie Baird conducted the first public experiment in-store of something he called 'television'.

synonymous with the assets and image of a founding family or personality. But it became increasingly clear that their radical display and distribution technologies and unwieldy departmental systems could no longer be powered by the impetus of lone individuals, however charismatic. Stores' commercial success had begun to strain at the margins of their original structure. The resulting enlargement of the businesses necessitated getting into more debt, making the stores vulnerable to hostile bids from other, more predatory companies.

As the shock of war receded, the British Museum and Selfridges would have to radically rethink their practices if they were to continue to structure the value of things.

In 1926, the Gordon Selfridge Trust acquired all of the ordinary share capital in Selfridge & Company, fulfilling Gordon Selfridge's ambition to amalgamate the nineteen retail distributors he had acquired over the preceding twenty years. Selfridge then made a daring takeover bid for 'Whiteley's the Universal Provider', one of the oldest department stores in London. On 1 April 1927, the takeover was successful.

Gordon Selfridge died on 8 May 1947, aged 91. Sensing a moment of weakness in Selfridges' trading position, the acquisitive Lewis's Investment Trust Limited bought Selfridge & Company for just under £3.5 million. This consolidated the process of shifting power from the owner of the store to its shareholders which had begun earlier in the century. Stripped of its autonomy, Selfridges now had to respond to the constraints of being just one of a number of going concerns in an investment portfolio.

Selfridges remained under corporate management until 1998, when it left the Sears Group to become an independent company once again.

Collision

In the present day, it is no longer possible to structure culture according to a reassuringly binary model. Just as ideologically, 'free' trade cannot be simply contrasted with the top-down command economies of 'welfare' states, so fine artefacts and antiquities cannot be opposed in kind to popular or domestic products.

Before the First World War, this kind of outmoded, oppositional model was perfectly embodied, and enthusiastically disseminated by the museum and the department store. The organisation of both institutions was built around static hierarchies of knowledge. Information passed slowly upward through their respective management structures, and decisions or reactions retraced its path downward and outward. Because of its inherent inflexibility, this 'top-down' system was only suited to the accumulation and classification of value through things as long as the nature of those things and the practices of shoppers/visitors remained fairly consistent.

After the onset of hostilities in 1914, these static principles began to dissolve, along with all the other comforting certainties of social and economic life. The patrician policies applied in the museum (defining and redefining its narratives for an educated élite, but with the expectation that wider society should also adhere to their definitions of taste) began to be superseded by a new interpretation of what 'doing' culture should actually consist of. But by employing essentially nineteenth-century management ideologies coupled with lazy exhibitionary practices, neither the museum nor store was equipped to adjust to this or any of the other vast cultural shifts that

Below: one of a world-wide chain of 'Museum Stores' in Hampstead, London

After the Second World War, economist John Maynard Keynes founded the Arts Council of Great Britain (the principal Government funding agency for cultural production). Using as its model the British Broadcasting Corporation (BBC), the Council was consciously intended to work in opposition to mass popular culture; Government-funded through taxation, its purpose was to ensure Britain retained a cultural sphere protected from the vagaries of the marketplace.

would follow in the decades after the end of the war.

This lack of responsiveness seemed particularly acute during the upheaval of the 1960s, as the pace of material life accelerated and the networking of electronic communication systems irrevocably began to alter traditional mechanisms of social, economic, sexual and intellectual exchange. As these changes washed around them, the museum and store may have adjusted in scale (downsizing occasionally in response to economic pressure), but still retained markedly unreconstructed, bureaucratic cores. Despite this complacency, events outside their doors precipitated radical alterations in the nature of the insitutions' respective constituencies. Both were having to face newly differentiated and multiple flows of shoppers, visitors and goods that produced fragmented and sometimes contradictory demands. The imagined mass of 'mass consumption' had fractured into lifestyle clusters, groups with requirements that could no longer be responded to with a rigid management hierarchy or single exhibition strategy.

Even the stores, which had been born with and were central to a networked promotional industry, remained hampered by antiquated management policy and a reactionary vision both of their own potential and that of their audience. They proved to be a long way behind the cutting edge of the accelerating market, generally defaulting to complacent ranges (selling muted tones and easy-fit to middle-aged suburbanites) by using merely the most convenient systems to acquire stock; buyers were sent abroad to sample passively the conservative wares of vast

114

corporate trade fairs. It appeared that the store, like the museum, could be condemned to lie remaindered in a cultural backwater, permanently disengaged from the active interpretation of the past and present of things.

In 1980s Britain, during the course of a single decade (an era characterised by what is known, normally pejoratively, as 'Thatcherism') Government policy destroyed the link between the reliance of 'culture' and its institutions on funding from the state, and introduced the market as a new disciplinary force. Museums were forced to respond to management discourses that encouraged strategies for mass participation, popular and entertaining exhibitions, 'blockbuster' displays and 'fun days out'. With a return to nineteenth-century museological policy and its focus on open access, State-supported cultural institutions faced greater pressure to produce what their audience appeared to want ('your visitors are your customers'), but without the imperative to educate, merely to entertain. Increasingly commercialised through entrance charges, branded exhibitions, and the necessity of wooing corporate sponsors, museums were forced to justify their funding through grants with direct reference to audience numbers and educational programmes; to become more 'rational' and accountable. They now marketed themselves as 'heritage' sites, as quasi-theme parks, full of 'interactive' push-button technologies. Much was made of museums' revenue-producing souvenir shops, relaxing cafés, corporate opportunities, promotional consultants, 'development teams' and retail tie-ins. At the British Museum, in popular tourist re-enactments

of excursions to the Great Exhibition, thousands of 'customers' – many of them schoolchildren or overseas visitors – thronged the marble halls, or jammed the 'signature' architectural extension. But behind this popular gloss, academic and exhibitions policy still showed an unchanging arrogance. The culmination of decades of social change seems to have been that the museum has moved towards the store in its market-orientated funding policy; and that the store (itself under pressure from other more efficient and stripped-down retail operations) has reverted to the theatrical 'exhibition' style of its beginning, concentrating on displays of sequences of 'lifestyle choices' that dazzle with promise.

We now increasingly play out our lives through what we want and display; ethical, moral and ideological 'choices' accompany the more mundane decisions of trying things on to see if they fit, or wondering if an item is affordable. The political imperative – expressed by phrases such as 'Green shopping', 'fair trading' or 'made using sustainable resources' – has as a result of fashion now become just another routine encouragement to buy. Participation in all the glitter of the intensified aesthetic present becomes a complex 'cultural' practice performed amongst a range of possible alternatives. The long history of convergence between the museum and the store is just part of a dissolution of the previously clear demarcation between the cultural and the economic. Indeed, any notion of the two institutions being radically opposed can now only be supported as an ideological proposition, rather than by reality.

117

Browse

'Ever since that moment when two individuals first lived upon this earth, one has had what the other wanted, and has been willing for a consideration to part with his possession. This is the principle underlying all trade, however primitive, and all men, except the idlers, are merchants. [...] Commerce cuts the way, and all professions, all arts will follow.' H Gordon Selfridge

From *The Romance of Commerce*, H Gordon Selfridge. Bodley Head, London 1918

'A museum is not a dead institution and anyone who accuses the British Museum of being dusty and boring is either ignorant or lacks a soul. The British Museum is full of life. To hundreds of thousands of schoolchildren it each year provides a sense of adventure; to millions of tourists and visitors it brings a sense of renewal, and to thousands of scholars a deep well of knowledge. It belongs to the whole world and is kept secure for all mankind.' Sir David M Wilson (Director 1977–1991)

From *The Collections of the British Museum*, ed. David M Wilson. British Museum Press, London 1989

Fragment
Section of a drawing board.
Limestone with traces of incised
gridding and catalogue number.
New Kingdom c.1550–1069 BC

Filler
Bowl with snap-fastening lid,
containing white, ready-mixed 'all
purpose' surface filler.
Polypropylene.
European Union 1998

Terminal
Possibly a housing for a gate beam. Sand-cast bronze, inscribed with the cartouches of Nekau.
Egypt 26th Dynasty, after 600 BC

Cat Flap
4-way locking, 'silent action', top-hinged doorway. Transparent plastic composition, multiple components.
China c.1995

Shoes
Military shoe. Leather upper, synthetic sole with encapsulated air, three-hole lacing system.
England c.1967–2000

Boots
Military boots. Leather sole and uppers with cross-laced fastening system, hand sewn.
Roman period c.30 BC–AD 395

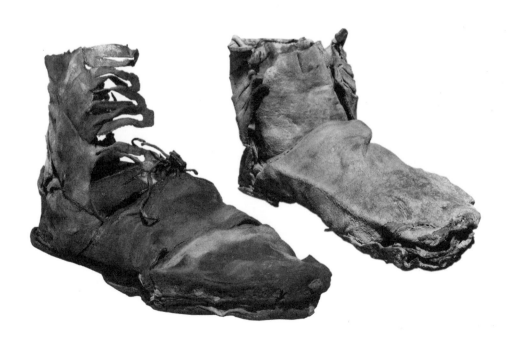

Spring [?]
Possibly a dampening device, or
housing. 10-gauge chromed
sprung steel, spiral construction.
Unknown provenance

Container
Hanging container (possibly
ritual use). Galvanised steel
mesh with rotation-moulded
plastic lid, riveted aluminium
additions.
China *c.*1996

Balls
Balls, multiple possible uses.
Linen wadding covered and
bound by reed strips; and gesso
and painted decoration.
Roman period Egypt c.30 BC

Dog
Bull Terrier (probable). Cast
porcelain, with additional fine
modelling, hand-painted.
Italy c.1994

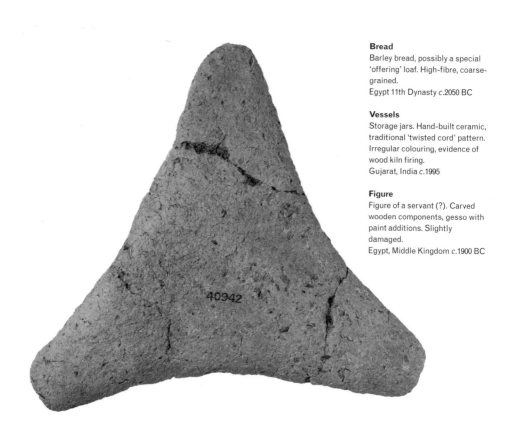

Bread
Barley bread, possibly a special 'offering' loaf. High-fibre, coarse-grained.
Egypt 11th Dynasty c.2050 BC

Vessels
Storage jars. Hand-built ceramic, traditional 'twisted cord' pattern. Irregular colouring, evidence of wood kiln firing.
Gujarat, India c.1995

Figure
Figure of a servant (?). Carved wooden components, gesso with paint additions. Slightly damaged.
Egypt, Middle Kingdom c.1900 BC

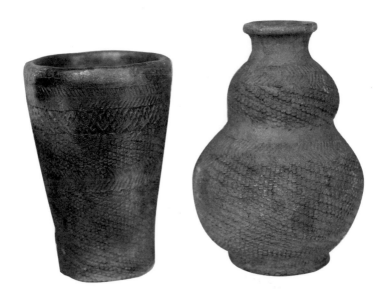

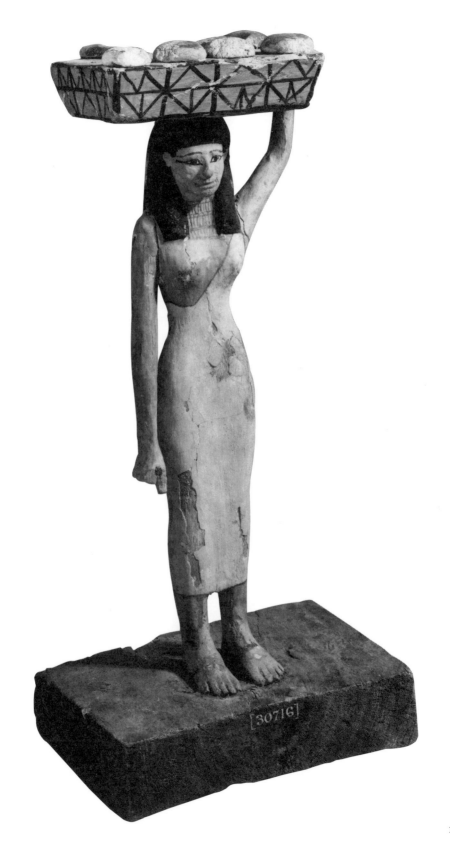

30716

Low Table
Mahogany (grown from
sustainable sources), traditional
H-frame construction, peg-
jointed and weather-sealed.
England *c*.1998

Mug Tree
Solid honey-pine stem on turned
base, with nine fitted horizontal
pegs, silicone wax finish.
England *c*.1997

Amulet
Twisted fibre core, with beads of
Cornelian, Agate and Calcite
composition. Occasional glazing.
Egyptian, Naqada period
c.3500–3000 BC

Boat
Model of a boat. Multiple carved
wooden components with paint
additions. Egypt, 12th Dynasty
c.1985–1795 BC

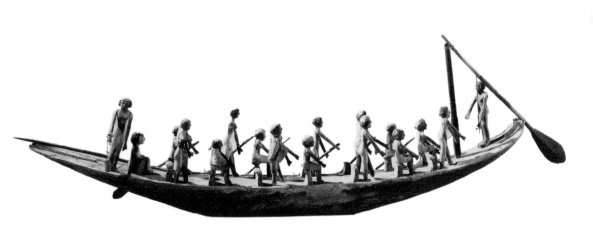

Sickle
Bronze sickle, handle (probably
wooden) missing.
Unknown provenance

Alternative Hair
Walnut colour, mixed nylon and
synthetic fibres, on a woven
mesh base.
Korea *c.*1996

Head
Cast wax head (possibly
representing an Ancient Briton).
Trimmed hair and glass eye
inserts.
England *c.*1970–1980

Part Three **Shopping**

130

Since its inception over one hundred years ago, the experience of shopping – purchasing as leisure – has steadily intensified. Aided by the unchecked expansion of the broadcast media, it has enabled every activity, every space, object, image and emotion, to be exploited as a potential retail opportunity.

Before the twentieth century, shops (coupled to the museum) quietly choreographed the exchange between commodities and customer. In our recreation of a nineteenth-century shopper, we could imagine a middle-class woman comfortable with her image of herself; wandering through the store, both rational and independent, she is confidently at ease within, and yet detached from the astonishing variety of things. In stark contrast, born into the era of a replicating promotional media, contemporary customers are made the restless casualties of their desires. Rather than merely 'buying' something, we are now encouraged to use every object or image to imaginatively extend ourselves; rather than making a purchase, in a sense, a purchase now 'makes' us.

Multiple technologies (advertising and in-store promotions) momentarily assemble and then effortlessly diffuse subjectivities – 'Is that coat me?' – as our personalities become radically distilled in fleeting moments of apparent choice. Constantly provoked and unsettled by the imaginative possibilities for new selves triggered by products and their attendant narratives, we can no longer maintain the illusion that we are in control. Instead, we are left only to try out parts in a bewildering range of aspirational product stories. Although still tainted by

131

its association with leisure and wastefulness, in this way, shopping has assumed a gloss of work and creation – the endless creation and re-creation of ourselves.

We are all sometimes paralysed by the possibilities of the shopping experience. Even if we think we already know what we want, the store can deploy multiple strategies to snag our intent. Meticulously designed and rigorously tested, display layouts create a disrupted and fractured field of vision, a restless gaze; the extraordinary range of goods and 'ridiculous prices' entice us to wander, tempting us away from our initial purpose and towards adjacent cascades of themed products. And as we browse, we glimpse fleeting reflections of ourselves, broken and fused amidst images of other shoppers, life-like mannequins, photographs and advertising promotions. The aching need we feel to see the reflection of an ideal image of ourself – the 'perfect fit' – is simultaneously stimulated and denied by the store's layout and architecture. The pleasurable drive to buy can easily turn into disenfranchisement and frustration: 'I want it, but I can't afford it', 'Nothing ever fits', 'It's always too expensive', 'If I get this, I'll need the whole set'; the shadow of potential disillusionment always haunts the fleeting pleasures offered by shopping.

Selfridges has recently introduced a service to help mitigate the effects of its potentially overwhelming in-store environment. Copied from America, 'Personal Shopping' is promoted as 'the ultimate shopping experience', one in which shoppers are equipped with their own consultant, backed by an experienced shopping team. According to the level of potential expenditure, it can be arranged so that the

132

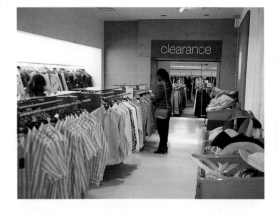
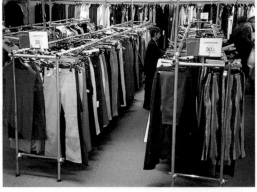

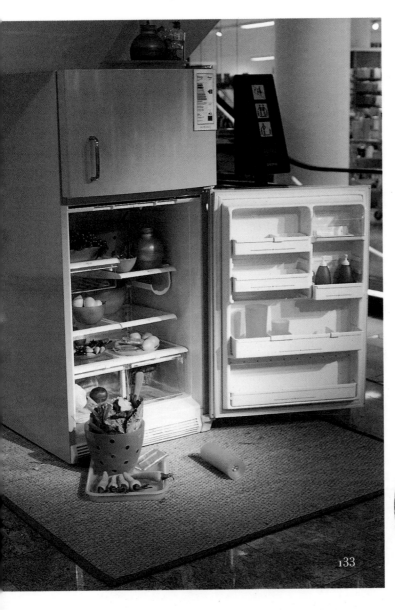

133

Dummy

All objects are signs for something else. What is unusual about the surrogate nipple offered to babies is that, in English, the word 'dummy' advertises the fact. (The Concise Oxford Dictionary's definition of a dummy is: 'a counterfeit object used to replace or resemble a real one'.)

The **NUK** Soother is claimed to be the result of 'research by doctors, dentists and scientists'. Given that this research has been directed towards maximising the dummy's simple capacity to soothe or pacify a baby, it is perhaps surprising that there is such an absurd variety of these nipple surrogates on the market. Some have flattened teats, others are domed, elongated, bulbous, or swollen and engorged. Could it be that the dummy eventually connects, like the portion of the person it replaces, to a latent erotic potential?

If so, then this eroticism is deferred or denied by introducing 'cute' graphics, garish colours and novelty promotions, in a weird adult projection of a baby's 'infantile' taste. In the case of the **NUK** dummy, this denial of the nipple's erotic potential is taken to another extreme by the sleek, streamlined form dematerialised by its transparency. This focus on technology seems more an articulation of the aspirations of the parents than a response to the needs of the child.

Although they are often found abandoned on streets the world over, dummies beautifully represent our hopes for all kinds of objects: they soothe the passage from the natural to the cultural. Not only do they complement nature (in the words of one manufacturer, a dummy 'is able to regulate feeds') but they supersede it (by 'discouraging the harmful effects associated with thumb sucking').

Consequently the dummy can become the focus of anxiety. Is its use ethical? Should you give one to your child, and if so, is this the most appropriate way to calm a fractious baby? When the dummy has the desired effect, most parents would agree that a cheap, ubiquitous plastic component becomes the most priceless thing in the world.

Store can be open out-of-hours, or more simply, someone can shop on our behalf, offering a pre-prepared selection of goods for later approval. But personal shopping is merely the advanced guard of a whole range of retail services aimed at broadening our potential as consumers. These new shopping technologies, particularly potent in the era of digital networks, are looking to extend our relationship with things outside of a physical and temporal grid, and into a limitless space characterised by indebtedness, loyalty and service. Customers who have signed up for Selfridges' Gold Card in-store loyalty and bonus scheme are guaranteed invitations to exclusive receptions of 'cultural' events that offer the chance to mix with clothes designers and fashion models, taste exclusive wines, preview current art exhibitions, attend book launches and signings, or enjoy tailored holidays and cruises. Rewarding the loyalty expressed by consistent in-store expenditure, this spectrum of privileged experience continually relates the Store to other cultural as well as economic spaces, dissolving everything in the context of 'value-added' opportunity.

TAXONOMY

There are always multiple reasons to enter the department store: the stunning display windows, the inviting curtain of warm air (and possibly the smell of perfume, coffee or bread) that greets us as we walk in, the glitter of trinkets just beyond the door, that special offer, a celebrity endorsement or book-signing, a make-over, the food counters, the café, the toilets or the baby-changing facilities. Once inside, the maze-like structure can be disorientating. Display

'Personal Shopping has a friendly and relaxed ambience. You will be made welcome in the comfortable reception, private fitting rooms and ladies' treatment room where you can make a booking for a massage or make-over. [...] Personal shopping is complimentary, with no pressure to buy.'

SELFRIDGES
Inspires Desires

Above: details from the Selfridges Personal Shopping leaflet, 1997

Customers Throughout the twentieth century, women's social position underwent radical changes. These shifts were precipitated by two principal factors: the decline in the use of domestic servants, and the increase in opportunities for jobs in the swelling number of shops and offices. Women were beginning to hold the purse strings: whether or not they actually worked for a living, through the performance of shopping (whether for staples or luxuries), they became

The fetishistic undertones of consumption might partly account for the intensity of the experience. Any act of consumption collapses down the two strands of fetishism as anatomised by Marx and Freud. Buying into a particular product – for example, branded shoes – is both an over-investment in that object: the shoes (over)compensate for the missing whole – Freud; and a marking of a site of loss, or alienated lack – Marx. Forever out of context, the object is a relic of a past wholeness it – or its purchaser – could never attain.

technologies and product proximities aim to create a 'pinball effect', bouncing the shopper from perfume, through cosmetics, around giftware and on into the interior, luring us deeper using the seductive potential of unfolding product sequences. Allowing for the odd regional idiosyncracy, the taxonomy of things demonstrated in department stores is remarkably consistent the world over – and ruthlessly structured by retail analysis.

In the 1940s, 'open' (using accessible shelving and display equipment) yet classified product displays altered the protocols that informed the exchange between customers and things. In addition, the significance of sales staff receded, as the change in display style accelerated a shift towards self-service. In effect, goods began to sell themselves as the skill of the salesperson was replaced by the seductive mechanism of display – the 'silent selling' of product plus promotion. As the retail revolution gathered pace, increasingly sophisticated merchandising broke with the departmental divisions of the old stores: the gendered split between mens- and womenswear, and the learnt structures of childrens clothes, furniture, housewares, 'casual' vs. 'formal'; and blunt segmentations by price ('budget', 'mid-price' and 'luxury'), dissolved into aspirational lifestyle clusters, 'branded' spaces and signature collections.

This eventually led to the current vogue for products being woven into distinctive narratives made up of seductive combinations of images, colours, and celebrity signatures. These fictions, such as that centred on the sunshine-drenched preppy American summer of sports and starched

part of a growing economic force. Consequently, women were also made more socially visible, as advertising (synonymous with the development of all consumer markets) addressed itself directly to their imagined desires, evolving specific strategies to ensure their commercial seduction.

Visiting department stores became associated with the authorisation to spend and luxuriate in the free time sanctioned by the middle-class accumulation of financial and material capital. The freedoms and

cotton, retain their power through constantly-evolving promotional campaigns and diffusion marketing. A range of clothes can now easily extend its brand into perfumes or other 'related' accessories. While shopping, customers are already well-versed in these stories; unlike the narratives of the museum, they and the systems of taxonomy and classification that support them, are inculcated from childhood onwards via the incessant white noise of broadcast media, images and information.

VITRINE

During opening hours in the modern store, every aisle has to be clear of boxes and packaging, any stockcarts or trolleys garaged; no visible trace of how goods appear must remain in public view. Display-management teams regularly police departments, making sure that the store's abundance has an almost magical aura. It is only 'after hours' that this lucrative illusion can be ruptured by the cardboard litter of wholesale distribution, as the store discreetly refreshes itself. Like the layers of bureaucracy that accompany the flow of things, the mechanics of distribution are hidden behind the scenes.

At times, the interior of the department store creates the impression of a casual confusion of things. But it is merely an illusion, masking the powerful application of the results of exhaustive retail analysis, coupled with the recommendations of extensive consumer research. Nothing is left to chance: every item, image, sign, display fixture, and the position of every service desk, point-of-sale and walkway is tested, and its effects on sales calculated. What we as shoppers encounter as subtle systems of

pleasures afforded women by these unsupervised (unlike in the museum) excursions were to characterise shopping as an activity that was neither clearly work nor leisure. In contrast, economic personae adopted by men prohibited any involvement in shopping, which was characterised as wasteful, frivolous and unproductive. Imagining themselves the engines of culture, middle-class men constructed roles that required participation, or apparent participation, in ceaseless work.

Allied to leisure, the practice of shopping slowly superseded necessity as the drive to accumulate things and, by association, browsing amongst the products of industry took on a distinctly feminine character. This may account for the attitude,

still prevalent today, that judges shopping to be a vacuous, unskilled activi[ty], unworthy of serious attention; even as its cultural significance grew, it was still to fall outside the proprietoria[l] boundaries of notions of 'work' as experienced and narrated, by men.

See *Why We Buy*, the book which purports to report on the 'science' of shopping, but which is actually assembled from observations gathered by Envirosell. Founded twenty years ago by Paco Underhill, Envirosell is a research and consulting company that sells its data about shopping patterns and consumer behaviour to retailers.[24]

correspondence, with goods sliding into one another as we browse, are in fact ruthlessly-planned retail mechanics. The contemporary store deploys these tools to reflect every customer, to profile and focus every desire: intimate concession areas are located next to more open, own-brand spaces; slick designer areas fold into exclusive franchised coops; quiet, middle-aged pastel spaces merge into sober haberdashery; and sparkling 'professional' kitchenware suddenly snaps into the blank seriality of matt-black electronic gadgets.

Nothing appears safely contained. Goods cascade through display fixtures of varying heights: wall-mounted shelving spills things down into low open cupboards, out onto tables or low plinths, or into buckets and bins. The resulting sequence of product images gives the goods a sense of animation, allowing them almost literally to 'walk off' the shelves. Colour combinations, correspondences in usage, 'neighbourhoods' of gendered products, price promotions and clearances also entice us from department to department. Exotica nestles with the more prosaic, and bright goods on eye-level shelves are complemented by larger items displayed above and below. Using the dramatic repetition of serial abundance, these stunning exhibitions seek to woo browsers into becoming buyers.

The vast internal floor spaces of stores are also broken up and structured by elaborate display fixtures. Pathways through goods are folded into looped patterns through which every department or independent retailer (operating a franchise) has access to the web of routes legislated by the walkways. Subtle changes in flooring assist navigation: cool

24. *Why We Buy*, Paco Underhill. Orion Business Books, London 1999

142

Credit

The early stores pioneered the eroticised exchange between people and things. An economy has emerged that is now the default setting of our promotional culture: seduction sells everything. The beauty of pleasure is that once engaged it cannot be contained: it seeps through other people and objects, encouraging us to buy and buy more. As seduction animates and routes our desires through things, we tend to want 'that which resists our

marble gives way to soft pastel carpeting, mid-tone vinyl is broken up with warm-wood floorboards; trails open and then fade as shoppers move through densely-woven groups of different franchises and concessions. Inserted into these 'rhetorics of walking'[25] are pauses where the customer is able to halt and contemplate deep vistas that open out through the vast floors of assembled goods, like momentary breaks in dense cloud. Armchairs, strategically placed, also invite longer, recuperative breaks in shoppers' journeys around the store.

As we walk, look, feel and try things on, localised music – restricted to specific areas by cleverly-tailored speaker systems – accompanies us, shifting from loud, up-beat funk into shuffling Latin, techno-muzac into generic 'classical', or breaking down into the jangle of teenage pop. Rhythm structures this aimless wandering, giving every look and gesture, every pause and comparison a filmic sheen: the music provides the soundtrack to a moment experienced as a knowing imitation of something else. Lighting is also an important tool for 'zoning' the shopfloor. Flatly institutional fluorescent lights, at one time popular for their ability to unify display spaces, are now being replaced by more versatile, theatrical clusters. Recessed downlighters mark out the pathway between displays, replaced in the exhibition areas by soft washes from more localised and warmer lights, themselves punctuated by the needlepoint shafts of low-wattage halogen bulbs that highlight 'standout' items from the main collection. This play of light complements the vocabulary of material finishes deployed across the range of the store's general fixtures. Sparkle, lustre and gleam are

143

25. From *The Practice of Everyday Life*, Michel de Certeau. University of California Press 1984

desire', the thing which is always just beyond our reach. We feel this gap as a lack, or a resistance to our desire to possess. If the resistance is too great (something is far too expensive) desire wanes; if the object yields too easily, it's too cheap, must be faulty, and we feel cheapened.

The gleaming product illuminated by the light of our desire allows us as shoppers to feel resistance as a value, a value that can be used to evaluate other goods and compare other people's desires through the

the glamorous evidence of attention lavished on chrome, stainless steel and aluminum shelving, finishes that dramatically contrast with the dull, light-absorbing matt and muted colours of the walls.

The display fixtures themselves also choreograph a subtly shifting play of space. Long views open up along transverse aisles only to be cancelled by walls of colour and merchandise; or our individual image is folded back onto itself by a floor-to-ceiling mirror, or captured and relayed through a wall-sized bank of linked video monitors. Aided by their display environment, goods alternately excite, absorb and seek to transform us. Shocked by sudden visual eruptions and the uncanny tricks of mirror reflections, confused by our appearance on a real-time video transmission, embarrassed by an encounter with a headless mannequin, in an act of giddy transference we turn from browsers into shoppers.

These techniques ensure the store's seductiveness, but others are also covertly at work to ensure that once triggered, shoppers' desires do not transgress into crimes of passion. In an echo of the museum masterpiece with its vitrine/shield, discreet security screws hold toughened glass sheets over 'highlighted' goods, uniformed guards are dotted throughout the store as visible deterrents, and the dark, reflective bubbles of the all-seeing eye of the CCTV system hang from ceilings on stalks, like mutant stalactites. Networked store-wide, digital surveillance gives security the competitive edge.

prices we are prepared to pay. As we connect with the object at the point-of-sale, all resistance is overcome and the value is consumed as pleasure through possession. If the goods obstinately resist – too big, too expensive, wrong colour – the

Stores are always changing, ceaselessly striving to re-configure their retail spaces so they can reflect and harness the aimless drift of fashion and taste. Restless managements roll out ever-changing programmes of improvement and expansion in an attempt to synthesise the illusion – one constantly under threat – that the store exists in a compelling, permanent present. Such an environment can never allow signs of wear and tear, the scars of the passage of time, to be visible to the public. This paranoia about the past extends to the products themselves. Old-style goods are kept safely classified as 'design classics' or 'collectibles', and 'ethnic' reproductions of artefacts are caricatured in the appropriate style. Ethnicity is teased into the kitsch'exotic', useless trinkets (often bearing a certificate of authenticity) become 'collectable', and reproduced 'old things' carry the patina of a fake antiquity. Abrasions, chips or scuffs, the visible signs of the passage of time, are simulated in a knowing parody of craftsmanship. But if these marks are made unintentionally, they instantly condemn the object to a shabby role in lines of 'goods to clear', or in discount bins of items sidelined as 'shop soiled'. The store luxuriates in the infinite present of the commodity, boxfresh.

The colonial unconscious of the store (as with the museum) is also ever-present, based on the guilty notion of a glorious past that can never be adequately recovered, or forgotten. The expansion of trade and power in the nineteenth century created an inequality in trading relations that remains in force today: Third World or developing countries are still used as manufacturing

A Carlton Television documentary broadcast on 31 September 1999, *Shoppers from Hell* described retailers' sophisticated surveillance systems as being aimed at deterring the 'casualties of shopping'.

Above: Santa's Grotto, Kids' Universe, Selfridges 1998

145

gap harbours all the feelings of frustration that accompanies the work of shopping.

Of course, some things that resist our desire gain a value which at the point of exchange they are actually unable to deliver. Think of the terrible disappointment when an intensely-promoted object – the latest pop CD, a new appliance, fashion item or book – after weeks of expectation eventually enters the store, and is revealed as a mere

shadow of its media image.
As a result, it fails to attract
an audience and slips quietly
into the clearance baskets.
 Credit as a technology for
the extension of desire has
accompanied the rise of the
department store. It allows the
customer to enjoy the experience
of owning the goods 'ahead of
time'. If you pay the price of the
product in cash, the money
expresses the sacrifice that the
purchase represents, but by using
credit, things are 'yours' before

the sacrifice is fully made; possession is traded for the anxiety of a payment deferred, by debt. Direct credit with the store — expanded by loyalty and privilege cards — is supplemented by a plethora of credit card companies, all of which offer the opportunity to luxuriate in objects for a deferred cost. Ownership becomes the equivalent of a gesture towards a postponed future of minimal monthly payments, the never-never. In a sense, we all live on credit now.

Model

For the ancient Egyptians, the afterlife seems to have mirrored earthly existence, and required the same equipment, houses, grain stores, tools, furniture, animals and servants. Painted wooden models (probably made in batch-production workshops) of a range of useful things were often placed alongside the dead in tombs. The models – symbolically at least – would allow the deceased to enjoy their earthly possessions in a resurrected life after death. Through the interpretation of the funerary models, museums the world over are able to reconstruct a clear picture of domestic life in the Nile flood plain.

Perhaps the most common burial artifact was the ceremonial boat, which enabled the deceased to travel across the Nile and on into the waters of the underworld to visit Osiris, god of the dead, and guardian of regeneration. An AD 1999 copy of

a Middle Kingdom model (originally made in about 1900 BC) depicts a ceremonial vessel taking the body of the deceased – with the attendant priest, servant and helmsman – on a journey into the underworld. It comes complete from the museum shop as a flat pack. Printed on thin card, the mass-produced model requires patient construction using scissors and adhesive tape.

Once assembled, can a clumsy reproduction carry all the potential of the version it approximates? Do all copies, no matter how pale their resemblance, point to their place of origin, and is that place of origin the model in the museum – itself part of a series – or the myth itself?

It seems uncannily appropriate that a model symbolising the quest for life after death, should itself be constantly remade in homes the world over: a modern domestic ritual of regeneration.

bases for European-designed goods and as sources for exotic products. A Selfridges promotion in 1999, the 'Global Tour', reminded customers that the Store's teams of buyers were out finding interesting and unusual products on their behalf, that they were 'Taking inspiration and skill from the countries, cities and towns they visit' (from the *Selfridges Media Pack* 1999); and in Soft Furnishings, a collection of cushions is accompanied by the text:

'Jerome Abel Seguin is a French contemporary designer who spends three-quarters of his time in Sumbawa, a small island in the east of Java, Indonesia. Over there he has built a small workshop. Using the traditional wood of Indonesia, Teak, he has crafted by hand this furniture. He has recently had publicity in all the home furnishing magazines: *World of Interiors*, *Elle Decoration* and *Marie Claire Maison* – and is the hottest name of the modern tribal design.'

Or similarly,

'The Richard Fisher Collection: Moroccan-inspired by the intricacies of the inscriptions of Arab poets. Revealing Arabian adventures, the story of Solomon and the Queen of Sheba, the celebration of the Alhambra itself and praise of the Prophet Mohammed and his family. The mood is festive, the pallet is a shimmering Moroccan sunset. A fascinating factor in this collection is that each piece of silk and velvet like a blank canvas, begins white.'

The physical occupation of non-European countries has merely been replaced by their economic exploitation, as stores and associated manufacturers seek to exploit differentials in labour, material and processing costs.

150

While contemporary buyers re-enact the mercantile romance of a previous age, the signs of this uncomfortable discrepancy continue to filter into the language of the store. There is no blank canvas, and it was never white.

In-store promotions are complemented by the traditional practice of interlocking the store's image into any number of ready-made advertising 'events' which might penetrate the consciousness of the media, but the nature of these is beginning to change. Previously, stores chose to appropriate the shiny glamour of blockbuster films, celebrity appearances, or spectacular advances in domestic technology. The idea was simply to trigger a mutual exchange between the potential publics of the store and the promotion's partner product. However, as the stakes of diffusion marketing are raised ever higher, such straightforward linking events between public and products are being replaced by more slippery synergies. For example, over the last few years Selfridges has extended its involvement in cultural events by forging sophisticated promotional relationships with museums and galleries.

For example, in 1998, the Store sponsored *The Warhol Look – Glamour Style Fashion*, an exhibition mounted at London's Barbican Centre Gallery. To coincide with the show, Selfridges themed its display windows using the silver Factory style of Andy Warhol's famous studio. Contemporary designers were recorded in simulated video 'screen tests', giving them their predicted 'fifteen minutes of fame', and a Warhol-inspired fashion shoot was recreated throughout sites in-store (and also appeared in a major Sunday newspaper that was co-sponsoring the exhibition), and

151

Far left: Korean Promotion, Food Hall 1999
Left: Thai Promotion, Food Hall 1999

Tate Modern, the most eagerly anticipated new museum in recent years for contemporary art in Europe, has opened a book and souvenir franchise in Selfridges.

In February 2000, Selfridges announced its plan to build a £500 million, 20-storey, Norman Foster-designed tower block behind the current store. The proposed development mixes bars, restaurants, retail and residential space with a panoramic public viewing gallery. The project echoes plans from over a century ago, commissioned by Gordon Selfridge himself, that included foundations for a dome as large as that of St Paul's Cathedral – planning permission was refused.

mixed live with a model agency casting shoot. In addition, customers were able to browse through the prominent food hall display of the famous Campbell's soup cans, Brillo boxes and Coca Cola bottles (which were accompanied by an exhibition of relevant Warhol prints), and screenings of Warhol's films accompanied appropriate merchandise promotions in the menswear department. In a strange synthesis, the shards of irony that lay at the heart of Warhol's practice were faithfully reproduced and disseminated via the promotion of new products, items re-visioned as the holy relics of a commodified past.

Alongside the more obvious support and promotional deals Selfridges offers to emerging clothes, fabric, furniture, cosmetic and utensil designers (particularly during the appropriate London Designer Weeks), the Store has also begun to engage with the contemporary art scene, encouraged by the rise during the 1990s of the media-active 'Young British Artist' (the now-notorious 'YBA'). Recognising the growing pliancy of contemporary art as a promotional tool, the Store quickly maximised its association with the artworld by using an independent commissioning agency to create links with galleries, museums, agents and sponsors.

A successful outcome of this new policy was the cultural cachet reaped by sponsoring the Serpentine Gallery in London during its recent refurbishment. This relationship resulted in further associations between the Store and individual artists, who contributed to new window displays, collaborated with Selfridges' design staff on internal schemes, produced work involving both video

152

and discrete installations, and endorsed the issuing of limited-edition products.

VALUE

Retail developments in the 1960s and 1970s enabled department stores to make enormous savings on advertising and merchandising by breaking up an undifferentiated mass of consumer desires and focusing them into more specialist clusters. The introduction of barcodes also meant that the movement of stock could be monitored item by item. For the first time, information and goods could be 'niche' targeted rather than aimed indiscriminately at an entire customer base. More recent innovations in the application of software to scanning systems have enabled stores to become even more responsive. The distinctive 'bleep' of the modern checkout signals the reading of the 'EPOS' (Electronic Point Of Sale) code of goods, a tagging technology that links information about sales to complex diagnostic software that is able to tailor systems rigorously for both the management and replenishment of stock. Consequently, merchandisers are able to build extremely customer-sensitive product ranges, and to identify and 'retire' poor-selling lines.

The supply flows of goods can now be interrupted in response to monitored sales data, even to the extent that adjustments can be made to the colour, size and pattern of particular lines during the manufacture of follow-on batches destined to replenish stock currently in-store. As a result, goods are made ever more responsive to actual sales, and are a clearer index of customers' desires.

Container

The bottle is characterised by its slight presence, its lightness, an absence of recognisable signs of manufacture, and often by transparency; in its apparent lack of material substance, the latest micro-thin polyester (PET) mineral water bottle hides the extreme concentration of forces which squeezed it into being.

With the bottle, our level of technical intervention has pushed down past the object and on into the particular sequence of molecules in the polymer chains of the material itself, so we are now able to design it to fit the object's function. The plastic can be made rigid, clear, spongy, brittle, flexible, absorbent or resistant as required, or any combination of the above. Thermoplastics are unlike other, more traditional materials; they act as a sequence of design potentials, potentials that do not find a physical form, have no 'raw' state, before the material/object is manufactured. In the factory, various chemicals are mixed, melted and squeezed under pressure into a mould, and then gasses blow the gloop into a thin film which expands to fill the mould, forming the desired container's shape. In a single alchemical gesture the material and the object are formed.

Contemporary plastics are perfect modern materials, ubiquitous and constantly mutating to absorb new properties; and yet our level of participation with them is inevitably kept on the level of mere consumption. Unlike traditional materials, with these kinds of plastics there is little possibility of DIY (except for a few crude sealing or casting products); we encounter them readymade in the shape of things.

Cantillon, an eighteenth-century French economist, formulated a curious paradox, one might say a Paradox of Value. How can the useless diamond be so expensive, and water, which is so fundamental to life itself, appear so cheap? Given the tiny unit cost of a plastic container and the vast expense of branded bottled waters, perhaps the paradox has migrated from the liquid to the containers that hold them. It is hard to reconcile the availability and cheapness of plastic containers, and the enormous expense of the images that promote them.

The
Marilyn Monroe
"Marabou"
Thong
100% Silk
One Size Fits All

by **WARNERS**

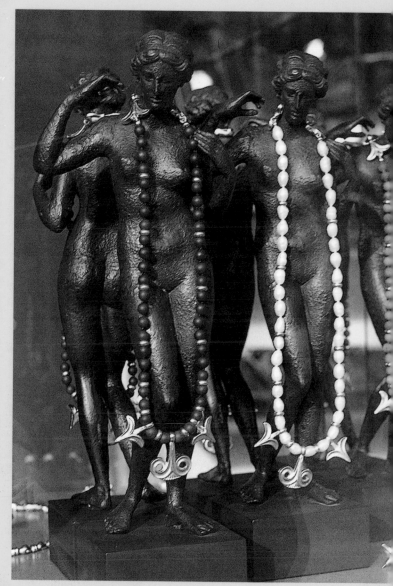

This encourages retailers to be increasingly nimble in their manipulation of the market edge. By trimming the time-lag between order, delivery and purchase from months to weeks (soon to be days), they are regaining control of the chain of supply to the point of virtually predicting future demand.

These new systems for 'just-in-time' replenishment also drive down costs: less risk is incurred by buying smaller quantities of goods, and both distribution and storage are cheaper. As a result, stock has been transformed from 'dead weight' into being represented as a fluid movment of things; it has been given the capacity to endlessly refresh capital. Reliable information-management and data-forecasting technologies have further revolutionised the interface between customer, product and store: 'PPT' (Product Performance Tracking) provides data on product sales, supplier performance and store efficiency; and 'EDI' (Electronic Data Interchange), a database interrogation system, scans the web of distribution, display and sales for inefficiencies and irregularities. Efficient purchasing and merchandising systems build a formidable information bank for the store that in turn encourages even more monitoring and 'dataveillance'.

This emphasis on flows of information, people, goods and capital has shifted retail attention away from the traditional fetishisation of a particular object or image, towards thinking about the process of value manipulation itself. Retailers are now able to calculate all the obvious and the hidden costs of sourcing a 'raw' material, of its processing into an object, and that object's subsequent distribution, exhibition, purchase, use and eventual

**Right: the Bridal
Registry, Selfridges 1999**

disposal – effectively to map the amount of energy in the transmutation of matter into products and back again. A material-as-object can do many circuits around the commodity loop, via charity shops, car boot sales and flea markets; but eventually, unless it enters a personal or museum collection, its matter will be buried, incinerated or, in the case of plastics, reformatted. Plastics have the most potential for this kind of prolonged, polymorphous life. After their primary use, they are capable of being sorted into separate families: polythene, polyvinyl, etc., before being ground, melted and then reconstituted into new objects. After several more transformations, the material begins to break down, and is then incinerated.

But even at the end of this cycle, manufacturing industries don't lose out, profiting from the 'recovery' of some of the energy expended in the production of the original material or object. Most plastics have a high calorific value, so the energy released through their incineration produces enough steam to power electricity-producing turbines. Growing the markets in recyclates will allow manufacturers and retailers to close the circle on the introduction of raw materials, their subsequent transformation into products, and the eventual recovery of their energy through burning. Seen from an overall perspective, the portion of energy being 'borrowed' by the stores is small; more importantly, the profit potential in such a heavily-monitored life cycle is efficiently extracted. The forces at work within the manipulation of things are beautifully encapsulated by this process of transformation. As consumers, it is our absurd investment in objects that

158

Fashion

The rise of the department store has been informed by the increasing power of fashion, and the penetration of style into every area of material life; from the seasonal fluctuation of clothes design, to the appropriateness of the colour of domestic appliances, even the humblest utensil is now subject to the drift of taste. Fashion encapsulates all the forces that motivate the movement of material things, as it conspires to ensure that every

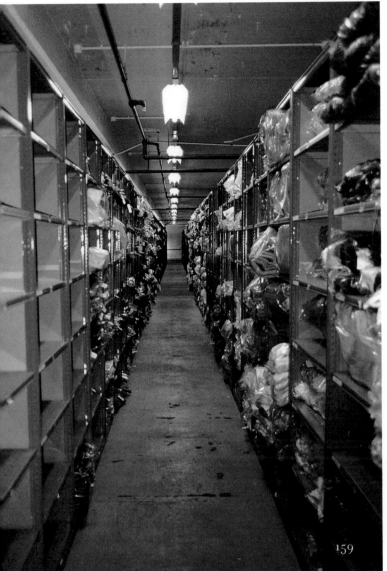

Left: the Warehousing and
Distribution Centre, Irongate Wharf,
West London 1999
Below: refuse, Lulworth Cove,
England 1999

purchase, look and gesture operates in a network of complex messages about aspiration and value — and gives those aspirations a sell-by date. In the past, fashion marked the passage of time in the material world by making visible the changing seasons; now, it gives every object merely a single blazing moment in media consciousness before it inevitably slides offstage. It has turned a linear flow into a cynical circuit, luring us forward by the ever-present promise of the new, the just-in, the fastest,

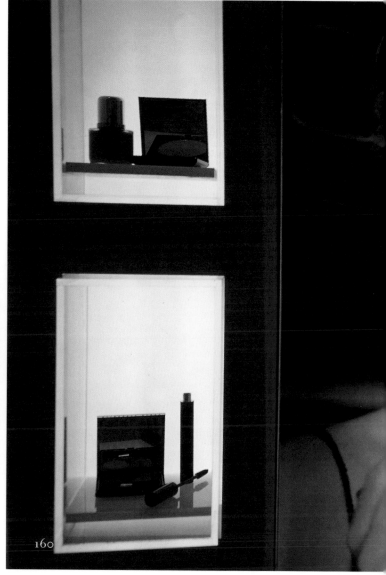

the biggest, the smallest, the re-mixed or the re-configured.

Most of us sense that fashion is shallow, shiny, insubstantial, supremely transient and trite; the most superficial segment of contemporary material culture. Embarrassed by our powerful emotional and monetary investment in the transient scum of contemporary culture, at the same time as we participate, we try to look away and feign disinterest. We would much rather our gaze was seen to be resting on the deep,

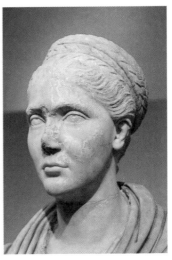

161

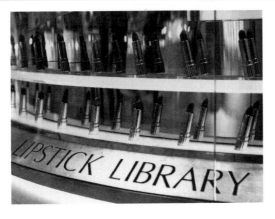

profound and stable artefacts of our museum-constructed past. The museum offers a kind of quarantine to objects, a refuge beyond exchange, with some symbolic resistance to fashion. As it evolved from a mechanism for

Imagine an inventory of all the materials, energy, emissions and waste production involved in the biography of an object.

blinds us to our role in the system we support: as nodes in the rapid refreshment of capital.

As circuits of people, manufacturing and information become more enmeshed, data tracking is able to monitor the capital following in products' wake. Cash is used less and less at point-of-sale, as the 'swipe' of charge cards electronically transfers payment direct from a personal to the store's bank account, and loyalty and discount cards exchange customer bonuses for information. The aim is to mine ever more efficiently the data that retailers already have, not only about what they sell, but also whom they are selling to. This avalanche of accumulated information is apparently collected to help streamline the store's efficiency, but the data is increasingly being recognised as a source of future trading, of potential new revenue. Future value resides in customer information and databases that can be sold as a commodity to marketing and promotional agencies, much like anything else. Projected possibility, the flow of information that follows things, is more encouraging to investors than records of past stock accumulations. In connected digital economies, the potential returns of an uncertain future are more attractive than a reliable past.

In these 'New Economies', predicated on the dominance of images and information, in which objects become the medium that carry the content (the logo, and all the longing it activates), the importance of the appearance of service intensifies. The rapidly-growing 'customer service' sector encapsulates all the 'value-added' experiences that surround contemporary exchange. In the context of a digital economy, the long tradition of the store making

reflecting changing taste into a medium, fashion quietly absorbed objects and images, and began to deform the values we had so patiently attached to things. Objects are no longer the means by which we can gauge the strength of our desires; fashion and promotion have turned them into mere carriers for images and information in the form of logos, brands and labels. Even more cruelly, by floating values free from the things that made them visible, fashion can seep into every aspect

us feel special as we make a purchase, translates into benefits for the provider, rather than us, the users. Promotions, bonus points on purchases, offers, tie-ins, celebrity events and deliveries all fall under the rubric of 'Services', and are customised to our preferences, tempting information out of us. As the store's meticulously efficient feedback loops tighten, the distinction between us and the products we purchase dissolves; desires and things as products blur. Retailers already know what you want – they informed the manufacturers last week.

BASKET, c.6th-10th CENTURY AD

of social life and distribute those values arbitrarily, over every work of art, space, taste and conviction. Fashion allows us to be aware of the arbitrary nature of the media present; of the eternal recurrence of the almost-the-same or, even worse, the emergence of a value and its immediate replacement with its polar opposite. For the forces of contemporary fashion, neither values matter. As an experience, fashion is now like a virus followed by amnesia.

rector...

harge of the whole Mus

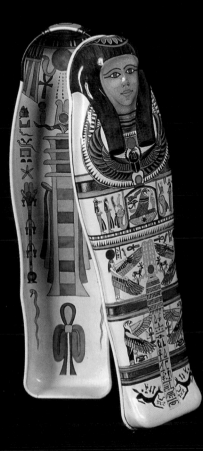

Warders...

look after the gallerie

museum safe. They h

who ask them the w

Cleaners...

start work at seven each

arrive. There is an area

thirteen football pitches

...and museu

cats frighte

the mice.

Like the store, the museum is generally visible only through its exhibition spaces, the public interface between the institution and its visitors. What is masked from view is the vast institutional machinery that acquires, catalogues, stores and interprets artefacts, as well as the administrative and service sections that facilitate those functions. The current structure of the British Museum comprises ten curatorial departments and two scientific research departments, supported by three different administrative departments: Central Administration, the Secretariat and Public Services. Together, its workforce – largely invisible from the public's view – totals some 1,100 people.

The split first felt in the 1860s between the public and private faces of the British Museum is now thoroughly ingrained in its institutional fabric. Although academic research allied to conservation is still at its ideological heart, the policies that characterise the Museum's attitude to the public appear to be driven more by the principles of leisure management and crowd control than by an ambition to educate, to diffuse the knowledge amassed at the core of the institution. Although open to the wider public, in practice this openness only extends to the objects on display. The Museum operates an unofficial vetting policy that normally requires academic credentials to accompany study requests to access objects in the collection. The only real opportunity for members of the public to utilise curatorial expertise is through the Museum's 'free advice' service, which allows private individuals to bring any object along for assessment (but strictly no monetary valuation) by world experts.

BRITISH MUSEUM STRUCTURE
Curatorial departments: Coins and Medals, Prints and Drawings, Greek and Roman, Medieval and Later, Prehistoric and Romano-British, Western Asiatic, Egyptian, Oriental, Japanese, and Ethnography;
Scientific departments: Scientific Research, and Conservation;
Education department;
Administrative departments: Central Administration, the Secretariat, and Public Services.
(The Secretariat provides support in areas of policy, law and logistics, and is also responsible for the Museum's central archive and library. Public Services subdivides into Press and Public Relations, Visitor Services, Photographic Services, and the Design Office; and also orchestrates the activities of an in-house printing facility, as well as teams of carpenters, glaziers, secretaries and security wardens.)

'Press and Public Relations raises the Museum's profile, enhancing awareness of its functions, policies and programmes in all sections of the Museum's actual and potential audience. It manages media relations, handles agreements with film and TV companies for publicity, educational and revenue-earning purposes; organises exhibition openings, corporate entertainment bookings; and manages sponsors.'[26]

26. From *The British Museum Review* 1996/98

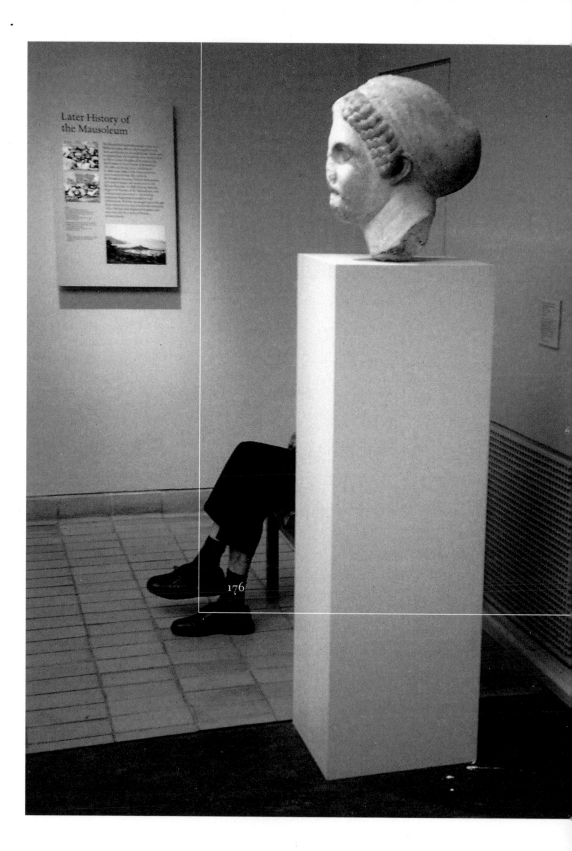

Members of the Museum's curatorial and research staff travel, study, lecture, exchange information (through academic papers and conferences), and excavate artefacts from all over the world. The results of this continuous research enters the public domain via the British Museum's Publications Department (formed in 1973), which produces some forty or fifty scholarly books and catalogues a year, along with some 500 'occasional' academic papers and journals. In addition, staff often advise Government departments and committees and present evidence in court or referee differences of learned opinion. As a result, the Museum continues to embody the perfect intersection of material things, State power and academic control.

TARGETS

Recent drives by European Governments to re-open the debate on public access to museums have in part responded to the widespread feeling that these institutions have evolved an 'élitist' culture. Ringfenced by their infrequently-challenged moral authority, the museums hide at their core a dead weight of institutional complacency. This attitude is born of the tired practices of an unengaged academia: arrogant, patronising, bureaucratic and obscurely scientific, it has increasingly squashed the potential of curatorial and exhibition departments to create the kind of vibrant displays which enable the public to engage actively with the interpretation of museums' collections.

Unfortunately, during the last fifteen years, widening access has been crassly interpreted as a need to increase visitor numbers, a policy that has ushered fashionable

The most visible manifestation of the Museum's commitment to academic learning is in the Students' Rooms that are attached to each curatorial department. 'Rustling with scholarship', these venues allow some 10,000 academics a year controlled access to objects, as well as to accompanying research materials, extensive departmental libraries, many generations of cataloguing cards, and various photographic archives.

'Museums in receipt of public funding and all museums registered with the Museums and Galleries Commission (MGC) should aim to offer the widest possible physical, sensory and intellectual access to their collections, subject to the safe well-being of the collections concerned, and subject to the resources made available to them. [...] All museums should set out in their forward plans their policy on access to their collections. They should publish and display in a public area of the museum the standards of access and service to which they aspire. Forward plans should also set out the measures being taken to extend access (such as research into visitor profiles, marketing strategies and exhibition programmes).'[27]

27. From *Access to Museums and Galleries*, a consultation paper on draft code of practice issued by the Department of Culture, Media and Sport (posted on the DCMS website), November 1998

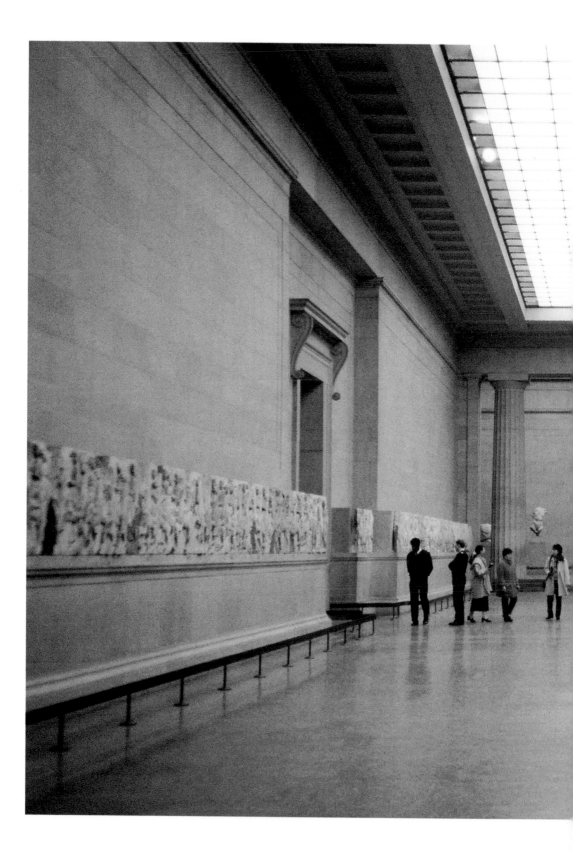

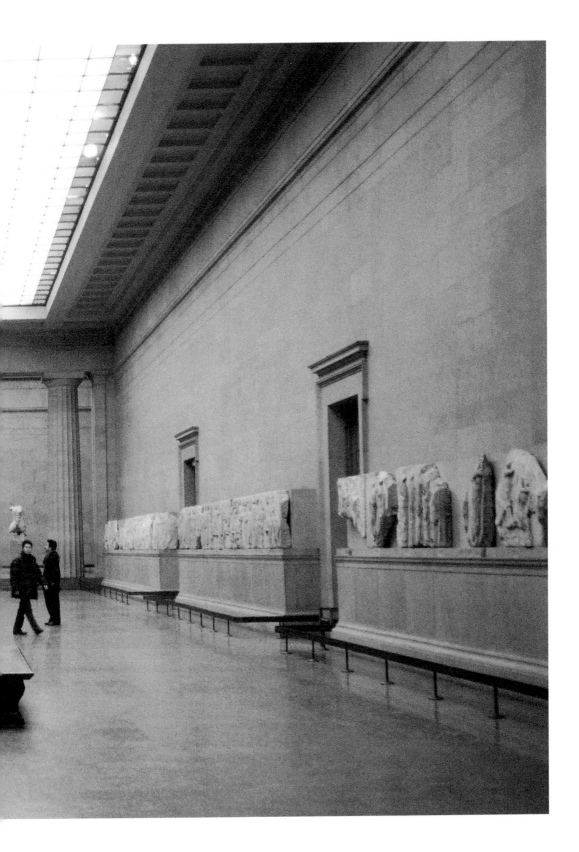

theories into museum management culture, based on the assumption that quality and control are easily quantifiable entities. According to this new creed, quality is no longer a notion to be defined by experts (élites or otherwise) but, instead, in terms of a system of service targets, marketing strategies and education initiatives. Approaches pioneered in the commercial sector have also triggered change in other parts of the culture of State-sponsored museums, perhaps most contentiously in the area of personnel. At the British Museum, trimming the 'institutional flab' maintained by cosy civil service employment codes has recently caused lower-grade staff to take industrial action. Compulsory redundancies have been issued in research and support departments, as 'job for life' attitudes are ignored by a 'new-broom' management style. To meet a stagnant or dwindling grant-in-aid, the Museum is following a general policy of cutting staff in its 'non-public' areas – all this during the largest expansion of the Museum and its services since 1820.

This exacting managerial principle of 'accountability' has also spilled over into the British Museum's educational and curatorial practice, resulting in a scramble for populist exhibition advertising and sponsorship tie-ins, in the setting up of an interactive 'children's gallery' (aimed at school parties) and, generally, in the creation of a more 'touchy-feely' interface with the Museum's public. As part of its current high-profile 'Great Court' redevelopment, the Museum has commissioned bigger gift shops and more restaurants and toilets: facilities that act as the gloss on a policy of apparent open access. In this way,

28. From speech posted on the Department for Culture, Media and Sport website, 10 November 1997

the Museum translates 'open access' to mean the creation of more services and retail opportunities, facilities that conveniently distract attention from its refusal to open up the ideological core of its practices to wider scrutiny and participation. Instead, its habits and traditions should be subject to both investigation and discussion, and its interpretative technologies attempt to engage a wider, less academic audience.

Stifled under the blanket authority of academia, what remains of the Museum's interpretative drive is now stunted by a scholarly fixation on the cold gleam of science: on a plethora of scanning, imaging and diagnostic technologies that present data as 'evidence'; by an obsession with dates, provenance, authenticity and cataloguing; and by inadequate funding. As a result, the Museum's tone remains authoritative rather than discursive – it lectures rather than discusses. Despite the best efforts of the Education Department, the challenge for the Museum remains for it to try to 'reanimate' its objects, to encourage its public to engage with the active reconstruction of the past in the present. Perhaps this would mean dropping the reliance on 'evidence' – the information emanating from the academic heart of the Museum – and, instead, making a commitment to discussion with a broad range of interest groups as a means of bringing museum artefacts into the realm of playful possibility enjoyed by things in contemporary exchange. This is not to blunt academic research, but to recognise its limitations.

The British Museum would need both courage and support to incorporate newly-democratised interpretations

181

As is common with other collections, 98% of the objects in the Museum of London's care are in storage. Under pressure from the recently Government-appointed head of the Museums, Libraries and Archive Commission, Matthew Evans, the Museum is to beginning to loan some of these objects to pubs, schools and restaurants in central London.

The British Museum Traveller (a
division of the BMCo) organises tours
on which museum curators offer their
services as expert guides to groups
visiting sites of archaeological,
anthropological or historical interest.

The British Museum
Traveller

1999

into its display and educational vocabularies. For example,
the Museum could choose to stage more temporary and
flexible exhibitions, theme displayed artefacts through
use rather than provenance, show the ancient alongside
the contemporary – and thus break the stranglehold
an outmoded chronology has on its collection. Through
such gestures and the elevation of interpretation to the
position currently held solely by scientific evidence,
the Museum could dare to rethink how its research and
scholarly activities dovetail into visitors' experience of a
material present. For people walking the galleries, artefacts
could be made to feel part of a more inclusive experience:
the things on display could operate as souvenirs of their
individualised past, rather than just that of an abstracted
group called 'humanity'.

Inevitably, with the installation of more prominent
visitor services the Museum's atmosphere blurs into other,
more tangibly retail-like territories for 'doing culture':
it is always crowded, and the act of browsing through the
displayed artefacts is accompanied by encouragements to
'see the catalogue in the museum bookshop' or to 'take this
treasure trail' or to join the 'Friends' of the museum by 'just
filling in your details'. But as other cultural spaces dissolve
into ever-finer market segments, opening up spaces and
narratives that recognise and celebrate the differences in
people and things, the museum still clings to its sly fictions
of chronology, order and evidence. Display fixtures and
technologies may flicker in and out of different styles
according to the vicissitudes of fashion, but the Museum's
central theme is always the same: the evolution of the

182

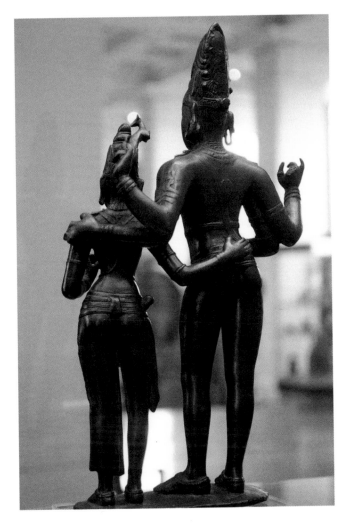

The British Museum was given £1.8 million for purchasing new acquisitions in 1997/98, a sum that had to be distributed between a hundred curators over nine collecting departments (figure from the *British Museum Review 1996/98*). In 1998, donations (from visitors and other sources) to the Museum amounted to £2 million.

As European institutions already struggle to compete with the fabulously well-supported American museums, fieldwork is viewed as a more economic means of gathering artefacts than purchase on the open market. The work of a growing number of amateur archaeologists often helps stock the British Museum via the 'Treasure Trove' principle. This stipulates that any article of gold or silver recovered on the British Isles that was buried with the intention of it being recovered, when recovered, becomes the property of the Crown (although an appropriate market value is often awarded to the finder by the Treasure Trove Reviewing Committee, advised by the Museum's staff).

culture of Europe, communicated through the exhibition of the material remnants of other cultures. Whether or not the museum is attempting to achieve 'access for all', it is a story that remains consistent the world over.

MERCHANDISE

Because State funding for public museums remains at a fixed level, it is actually receding in real terms, year on year. To supplement either precarious or stagnant public expenditure, museums have become active in seeking corporate sponsorship and private gifts, in increasing their diverse trading activities, and in introducing admission charges for temporary exhibitions. The British Museum has been particularly effective at capitalising on its cultural stock to create revenue streams from 'diffused branding' operations. The British Museum Company (BMCo) is owned by the Trustees, and charged with furthering the charitable and educational objectives of the museum through the raising of funds. With an annual turnover in 1998 of £9 million (of which £1.7 million was covenanted profit to the Museum itself), its activities encompass publishing, retailing, travel and merchandising. The Museum's publishing company has a list of some three hundred titles – ranging from academic monographs and exhibition catalogues to children's books – and co-edition and licensing contracts with over eighty publishers world-wide.

The sale of museum merchandise is made possible through a range of shops, distributed at various sites through the building, a retail operation that has recently been extended via the installation of an outlet at London's

184

Labels

Things as commodities are in themselves empty of significance (although they occasionally have utilitarian uses as technology). As a consequence, a vast superstructure of images and documentation, information and commentary has grown up around objects to locate them amongst ranges of extremely similar things. Labels, names, logos and signatures are a means of authorising an object for retailers and their suppliers,

Heathrow Airport (the seed of what might well become a chain). A separate marketing division is responsible for the manufacture and distribution of a wide range of souvenirs, clothes and postcards based on the Museum's collection, either through direct replication or a more allusively-themed relationship. The wholesale part of the business is currently rapidly expanding by exhibiting its products at trade fairs throughout Europe and North America: a recent contract has secured promotion of the Museum's products with QVC (Quality Value and Convenience), the 24-hour US-based shopping channel. BMCo's core activities are complemented by an expanding licensing programme that deals with further replication of works from the collection by 'preferred' manufacturers. Direct distribution of products is also possible through an extensive mail-order catalogue, which is currently in the process of gaining a presence on-line.

General merchandising based on the British Museum's core collection is supplemented by the 'Facsimile Service', which creates replicas of objects for other academic institutions world-wide, or on the request of private individuals or, increasingly, of trade customers. In response to increased pressure to commercialise its activities, the Museum is also beginning to recognise the lucrative potential in the licensing of images of objects taken from its vast photographic archive. It can only be a matter of time before this sanctioned usage extends to the vast data stores represented by the information on the Museum's card-cataloguing systems. Over the last twenty years, data referring to some 1.7 million objects from the collection

Various licensing agreements sanction 30 stores in Japan to stock British Museum-endorsed products.

allowing both them and their customers to locate points of difference amongst the standardised goods of industrial manufacture. By attaching notions of consistency to the image/product, this promotional

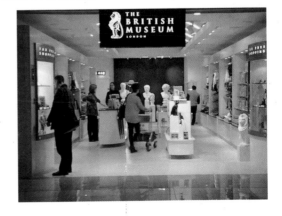

F · EGYPTIAN HIPPOPOTAMUS
The hippopotamus was identified in Egyptian mythology with Seth, the god of storms and violence. Perennial favourites, these eye-catching hippos are copied from originals made about 1850 BC.
Glazed earthenware. Made in England.
R90810 Small Hippo (2¾" long) £8.95
R90800 Large Hippo (6" long) £33.95

G · EGYPTIAN EMBOSSED NOTECARDS
A boxed set of 6 cards with envelopes, featuring two different Egyptian designs. Beautifully embossed cards for any occasion. Blank inside.
7" x 5".
S55670 £4.95

H · SMALL EGYPTIAN CAT
The cat was the sacred animal of the goddess Bastet. This popular replica is of an Egyptian cat from the Ptolemaic period, about 200 BC.
Resin with base. 5" x 2½" x 3½". Made in England.
R90880 £24.95

I · EGYPTIAN BES
This comical character was one of the ancient Egyptian gods relied upon to protect and bring happiness to the house, and to guard against the danger of snakes and scorpions.
Glazed earthenware. 4" high. Made in England.
R90700 £9.95

J · EGYPTIAN GIFTWRAP
Make your gift unique with this Egyptian papyri wrapping paper.
6 sheets (27" x 19") with 6 matching gift cards.
S55590 £3.75

K · HIEROGLYPH SCARF
The hieroglyphs in this design are from the tomb of an Egyptian high official, Ptahshepses.
Pure silk with hand-rolled hems.
11" x 54". Made in China.
T56760 Black/Beige £14.95
T56040 Navy/White £14.95

Above: the British Museum Gift Catalogue 1993/94
Right: the Museum's Photography Department producing images for documentation and reproduction.
Lending out images of objects in the collection is a lucrative sideline.

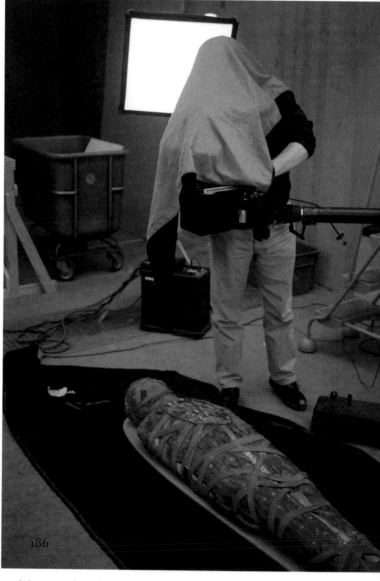

186

superstructure can deploy ideas of value, quality or style as appropriate. Once established, the difference between the images of things can be built upon as a foundation for trust by manufacturers, retailers and customers alike; essentially, as a means of offering some purchase on the stream of merchandise that constitutes modern material life.

In the nineteenth century, stores began to obtain exclusive rights for particular merchandise. The subsequent 'branding' of both the store

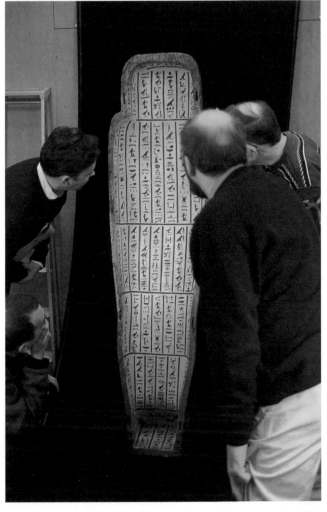

187

A head said to resemble that of Sophocles (a Roman copy *c.* AD 100–120 after a Greek original, and now in the Townley Collection) can be reproduced in white plaster for £185 + £50 carriage fee within the UK. Other prices can be quoted for any of the three thousand casts available.

and its products, translated through identification into loyalty. Manufacturers and retailers soon began to realise that once trust had been established, via the label, it could be extended to other adjacent products to build a range

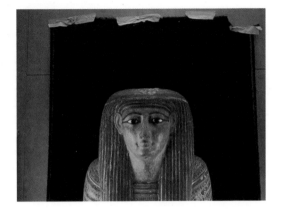

of similar goods; and eventually if the brand were carefully nurtured, to authorise a collection of totally disparate things. But as the struggle for loyalty and difference transferred from the products to the stores themselves (different from one another in a particular city, country and eventually, through global tourism, the world over) a complete range of objects had to reflect the store's aspirations for itself. So stores mixed their 'signature products' with premier designer floors, and built

has been transferred onto digital media, while all the Museum's prints and drawings are described in digital form, ready for retrieval; similarly, for new acquisitions, the old ledger-entry system is being replaced by 'on-line' registration. While information is exchanged with other academic institutions without charge, the British Museum also sells data for commercial reproduction. Although, as a public sector institution, it is forbidden to borrow capital against the assets of the collection, the Museum is nonetheless engaged in turning that collection into a revenue stream.

RETAIL

As a means to further supplement funding, the British Museum Society aims to develop a body of 'Friends' to support the Museum's collecting, research, conservation and education programmes. A scheme introduced in 1998 to try to broaden the Museum's financial base instigated various hierarchies of public donorship. Each year, Friends receive the British Museum magazine and invitations to select evening openings, special lectures and behind-the-scenes visits, as well as being offered the exclusive use of a members room in the building's East Wing. 'Associate members' receive all of the above privileges, as well as a Director's invitation to an annual reception and access to other exclusive events. Inevitably, gifts or sponsorship place the Museum in a situation of indebtedness. In response to specific donations, various parts of the collection are extended or brought more forcefully into public awareness: for example, during

189

carefully-edited 'own brand' merchandise ranges to complement select concession areas.

The superabundance of objects initiated by the wealth creation of the 1960s intensified our reliance on labels to identify the 'marginal differences' between series of what are essentially the same things. Superficial differences are now all we have left. The labels through which we can slowly learn to trust an item appear on a bewildering

the economic expansion of the 'tiger economies' of the Far East in the late 1980s and early 1990s, the Korea Foundation sponsored the restoration of one of the Museum's galleries to display its culture's artefacts. As a result of this essentially reactive policy, what could be termed 'core collecting', the building of coherent holdings for future generations, has all but ceased. In its place is the policy of the 'highlight' object: funds coaxed from charitable or commercial institutions support a particular purchase, direct attention to a specific artefact, or display a highlight sequence from the collection. Lottery applications – the 'golden goose' of contemporary British arts policy and funding – hold the promise of endless extension and refurbishment but no support for core activities: acquisition, research, conservation and interpretation. With little stable investment, how can public institutions plan for a coherent future?

Besides the main building in Bloomsbury, the British Museum's collection is stored at two other main sites in central London: at Hoxton in the East and Hammersmith in the West. Both stores are full to bursting with a stunning variety of artefacts. Contrary to received opinion, the stored things are of no less importance to the collection than the objects on display, and need to be regularly consulted by researchers and academics. In 1994, in a bid to rationalise storage and improve access, a new site was acquired five minutes from the Museum (in partnership with a commercial property developer under the Government's Private Finance Initiative) that was large enough to house the whole collection and still leave space for its projected expansion over the next fifty years. Proposed plans

range of related products. As you browse the store's aisles, a label you recognise as an indicator of reliable shoes might also mark a collection of knitwear, bathroom fixtures, a kitchenware range, paint, or a selection of children's clothes. If all 'lifestyle' product ranges are essentially the same, made in the same factories by the same processes, workers and materials, only branding separates one from another. Logo and label represent the smallest graphic

encompass a tiered development for storage in the basements, leased retail units on the ground floor, a new interactive Study Centre above, and a hotel above that – a scheme that promises to encapsulate the inevitable trajectory of future retail culture.

The most recent of the Museum's capital developments, the Great Court Scheme, is timed for completion in Spring 2001, to coincide with the British Museum's 250th

The British Museum Development Trust raised £95.7 million – matching the public lottery grant – for the Great Court Development.[29]

29. Figure quoted in the *British Museum Review* 1996/98

glyph that enables you to differentiate amongst all the potentials on offer. The only common factor in a 'diffusion product sequence' is the image they distribute.

As long as the trust between image and customer is not abused it is only a matter of time before stores and their suppliers extend that trust beyond a collection of objects into a sequence of other images, spaces, smells and lifestyle choices. Building labels is the clearest evidence for

anniversary. Opening up the heart of the museum building, which until recently was taken up with the bookstacks of the British Library (40% of the 13.5 acre site in Bloomsbury was freed up by the library's recent move to new premises), the scheme will create a major new cultural space for London. Designed by Norman Foster, the complex will comprise bookshops and cafés, special exhibition galleries, and facilities for the Patrons, the British Museum Society and Friends organisations. A Centre for Education will form the cornerstone of the development, sited opposite new galleries displaying articles from the African Collection (returned from the Museum of Mankind in Piccadilly). A new Public Information Centre (due to private benefaction to be known as the Walter and Leonore Annenberg Centre) in the Round Reading Room – open to the general public for the first time in its history, will support and expand the technologies of the education departments.[30]

The centre, with its democratic remit to accommodate all visitors, is intended to transform the way the Museum communicates with its public. Traditional methods of data retrieval: the old departmental libraries, photographic archives and expert staff, will be complemented by the latest in digital technology, as well as information systems promoting current and forthcoming events: lectures, films, courses, seminars, concerts, family activities and conferences. While many of these new and interactive technologies are to be welcomed, there seems little breathing space for the larger question: 'Access to what, and why, and under whose authority?'.

192

the means by which things have been superseded by images and information. Brands clusterbomb rival product lines, advertising and promotion as images constantly support, inform, cajole and reward consumer choices. The cachet of identification is so strong that labels have become self-supporting revenue streams. It is now the sign you pay for, with the object it is arbitrarily attached to given away free – a gift from the retailer to you.

'In an age of popular culture [the museum] expresses in the visitor the sense of man's achievement in the material world by showing the art and artefacts themselves, not cluttering them with explanation in many languages and for many ages, but with information sufficient to provide the intelligent person enjoyment, satisfaction and awe.'[31]

LEISURE

During the golden years of the British Museum's expansion in the latter half of the nineteenth century, on an institutional level it was intended that visitors used the collections in a very prescribed way. Exhibitions were designed to educate an ambling public with logical displays that employed objects to illustrate and reinforce prevailing attitudes towards both history and contemporary knowledge. The policies that created these displays were predicated on the expectation that well-educated visitors had some knowledge of the myriad of stories that were woven together to classify, exhibit and narrate artefacts into their respective places. This knowledge might include information on connected historical contexts, different thematic or stylistic schools, particular groups of or individual artists, aesthetic conventions and patterns of taste, various systems of social organisation, interconnected forms of patronage and production, economic structures and the rudiments of geography. Having been taught the necessary values by networked institutions for public education – schools, universities, libraries and other museums – such visitors had the ability to locate artefacts within a dense field of complex representations.

No longer armed with a such a secure grasp of history, and possibly confused by the concurrent processes of social fragmentation and globalisation, contemporary visitors cannot readily respond to museum objects (many of them the spoils of a brutal economic colonialism) in the same way as their predecessors. And in the attempt to accommodate the differing needs of a no-longer homogenous public, the

193

30. *For the Love of Art: European Museums and their Public*, Pierre Bourdieu and Alain Darbel (Polity Press, Cambridge 1991), is excellent on the role education plays in access to and deployment of cultural competence

31. From the introduction to *The Collections of the British Museum*, ed. David Wilson (former Museum Director), British Museum Press, London 1993

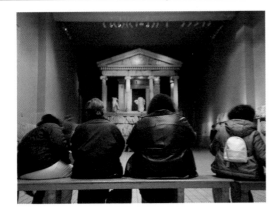

January 1974 saw the imposition of admission charges at the British Museum, previous attempts having been abandoned in 1784 and 1923 respectively. The 'experiment' was curtailed in March of the same year, as attendance dropped dramatically. The spectre of admission charges continues to linger at the edges of debates about museum policy, along with all the attendant ethical issues related to access and freedom.
A change in the National Curriculum of England and Wales in 1990 has tripled the number of school children visiting the British Museum. The prescribed curriculum for schools dovetails into the Museum's collection, forcing its Education Department to divert more resources into the distribution of teachers packs, teacher training, the mailing of introductory videos, supplying interactive multi-media and tending internet pages. 129,000 pupils attended as part of booked school tours in 1998.

museum experience is inevitably dissolving into one that can be equated with the 'grazing' activity of the generic tourist. Detached from the narratives that used to hold things in their place, and adrift in a relaxed leisure-like ambience, we now expect entertainment: animate these old things or boredom beckons. A trudge through the long galleries in order to visit an exhibition of national heirlooms needs to be relieved by a thoughtful 'feature' display, if the risk of a cup of tea being more compelling than the exhibits is to be avoided. The experience of 'doing culture' – looking at the artefacts, following the guide, reading the labels, photographing and being photographed – is slowly being augmented by a whole set of practices more closely related to other kinds of leisure activities.

The pressure to turn modes of exhibitionary consumption into something akin to a leisure experience is now forcing the British Museum to implement new technologies to entertain and amuse its visitors. Audio-visual guides, walking tours, family and children's workshops, touch-sensitive data screens and video loops all combine to construct a platform of interactive media. But there is always disagreement about what should and what shouldn't be supplied in terms of contextual material in exhibitions and galleries. Tourists and children enjoy all kinds of supporting material that helps them access the artefacts and the context from which they (both the artefacts and the visitors) are otherwise divorced. But a commitment to displays that employ overtly 'accessible' methods of presentation prompts complaints from visitors who have been educated into the expectation that museums

194

should be pared-down contexts for the 'pure' contemplation
of objects. These people tend to complain that didactic
material hinders their experience of the museum,
interfering with a correct, concentrated mode of looking
at things. This ideology of the pure aesthetic experience –
based on the assumption that visitors should already be
familiar with the narratives that make these artefacts
important, valuable or instructive – is a charismatic one
for 'competent' museum users.

For academics, seeking to hide – or, more often,
obscuring – the learning involved in 'cultural appreciation'
is like covering your tracks. It is this that differentiates
the mode of museum visitorship from other types of
'cultural' activity: the information necessary to engage fully
with the narratives on which museum displays are based
is not available via the broadcast and promotional media,
but solely through the connected institutions of higher
education: universities, colleges and other museums. In
terms of access, this accounts for the under-representation
of certain social groups. Contrary to current Government
thinking, this discrepancy is not caused by a lack of 'open'
access, but by a more profound problem: a lack of access
to education. Without the encouragement to gain this
access for themselves, and to thus allow them to invest
in the narratives that issue from the institutional core of
the Museum, many visitors can do little to resist the glib
retailisation of their experience of their cultural history.

SPECIAL OFFER

25 % OFF

Discontinued
Lines

SELFRIDGES

Giftware

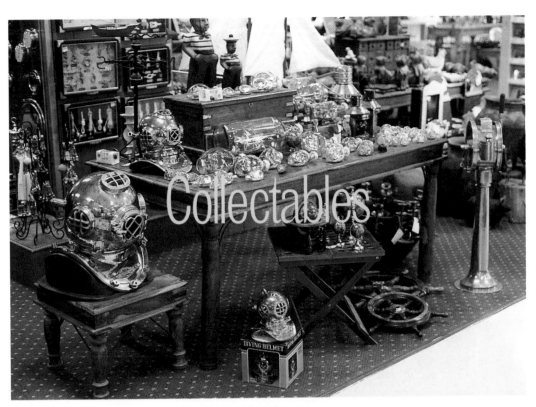

Collectables

Prints and Drawings

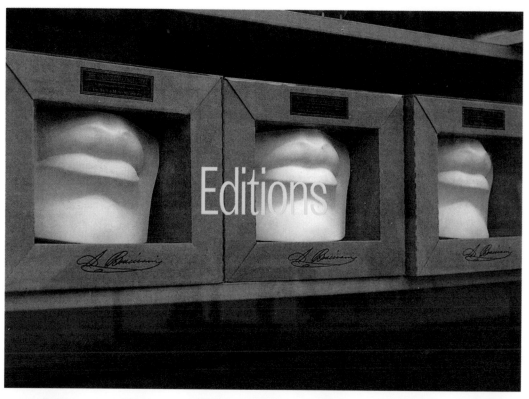

Editions

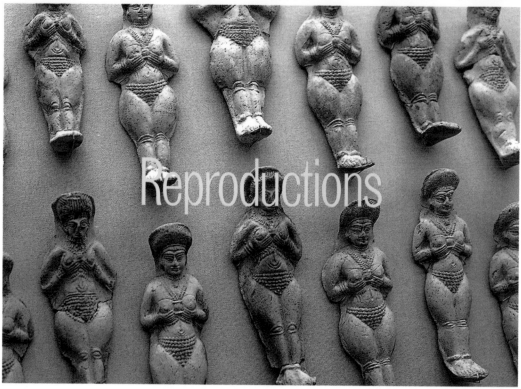

Reproductions

Multiples

Consumables

Antiquities

Reference

Upgrade

WELCOME

'On the eve of the twenty-first century, this great institution is uniquely placed to become a truly global resource.'[32]

In an age of digital connectivity, the infinite possibilities allowed us by new communications technologies are resulting in a change in our understanding of objects. Value can no longer simply be expressed as the accumulated excess of labour, an excess 'stored' in material things. The stockpiling of value as gold in banks, or as objects in museums, homes and stores, is becoming increasingly abstract: this thinking relates to a time characterised by the relatively slow, unconnected circuit of things through the museum and the store. In the context of a world-wide network, old habits are having to be adapted as everything becomes linked to everything else.

Over the last five years, the much-heralded globalisation of access to technology and information has mirrored the increased deregulation of trade tariffs and the movement of money, the opening up of Asian and former Communist-controlled markets, and the consolidation of Europe as a single trading block. Against this background, circuits of production and consumption are fusing to enable objects to exist in a permanent state of immanent possibility: when manufacturers already know what you want, things are no longer distinct from your desire. At every moment of their lives, products – no longer just material objects but also

203

An unease produced by the dissolution of certainties imagined in a former age isn't just an invention of theory – it's an anxiety that can be located in current popular consciousness (most often cloaked in irony). In the first of the two *Toy Story* films, the character Buzz Lightyear thinks of himself as a heroic spaceranger with a unique mission, until the shocking realisation dawns, via a television commercial, that he is a toy-product identical to millions of others. This anxiety resurfaces in the sequel, where Woody, another protagonist, is presented with a terrible choice: to remain for eternity preserved as part of a museum collection, or to lead a short and brutal, but loving, existence adrift in the everyday flow of things – Woody chooses life. The twin narratives of *Toy Story* take on an added complexity when we are reminded of the films' strange status as objects. Considered the first fully-digital animated features, the films' characters, locations and action were all modelled by computers and 'written' directly onto the film, thus totally bypassing the camera. Consequently, there is nothing but a sequence of computer code to act as an origin for the multiple copies of the films, their staggering promotional campaign, and the multitude of products that indexed their massive popularity.

services and potential services – are tracked as part of a supremely responsive system for monitoring the efficiency of process, advertising and purchase. As a result, the threshold between a product and its promotion becomes increasingly difficult to identify. Upgrades constantly re-tune ranges in response to the ever-vigilant watch kept on desire by consumer research, and fluctuations in demand animate hair-trigger campaigns that exploit new windows of opportunity. In this system, nothing is intended to last; everything must be able to adapt or be disposable.

A super-connected digital economy means that the old binary rule of wanting something and having to pay the price dissolves in the complex exchange of information via 'offers', devices to offset and defer the payment of desire's price as expressed through money by negotiating a swap of information at the point-of-sale. To exploit the new opportunities this presents, the store and the museum are both developing technologies to establish an ongoing 'relationship' with us via reward deals, donor and sponsorship societies or special privilege cards, all schemes that promise to keep us informed and invite us to special events, in return for our comments and a contact address. These 'relationships' are part of the institution's desire to build data maps of individualised taste (portraits of customers built up from the details of their habits of consumption), to turn this information into knowledge, and to feed that knowledge into the creation of future products.

In a networked electronic economy, knowledge is the new source of value; not to hoard – as in a material economy – but to share, sell or reconnect with other retail sites.

32. From *Planning the 21st Century*. British Museum Press, London 2000

204

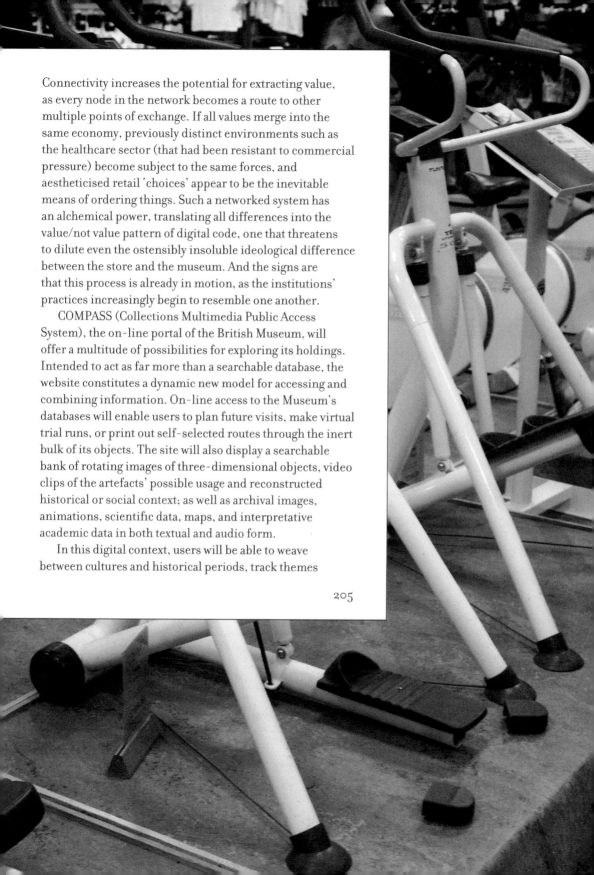

Connectivity increases the potential for extracting value, as every node in the network becomes a route to other multiple points of exchange. If all values merge into the same economy, previously distinct environments such as the healthcare sector (that had been resistant to commercial pressure) become subject to the same forces, and aestheticised retail 'choices' appear to be the inevitable means of ordering things. Such a networked system has an alchemical power, translating all differences into the value/not value pattern of digital code, one that threatens to dilute even the ostensibly insoluble ideological difference between the store and the museum. And the signs are that this process is already in motion, as the institutions' practices increasingly begin to resemble one another.

COMPASS (Collections Multimedia Public Access System), the on-line portal of the British Museum, will offer a multitude of possibilities for exploring its holdings. Intended to act as far more than a searchable database, the website constitutes a dynamic new model for accessing and combining information. On-line access to the Museum's databases will enable users to plan future visits, make virtual trial runs, or print out self-selected routes through the inert bulk of its objects. The site will also display a searchable bank of rotating images of three-dimensional objects, video clips of the artefacts' possible usage and reconstructed historical or social context; as well as archival images, animations, scientific data, maps, and interpretative academic data in both textual and audio form.

In this digital context, users will be able to weave between cultures and historical periods, track themes

205

On 13 May 1999, the Department of
Media, Culture and Sport launched the
networking of 2,000 museums across
Britain. Promotional material for this
24-hour on-line museum gateway
claims that it will facilitate access to
the country's entire cultural history:
www.24hourmuseum.org.uk

The British Museum Report of 1996/98
notes that the museum's website –
www.british-museum.ac.uk – records
a similar number of visits each week as
the physical collection in Bloomsbury:
115,000.

or specific objects, make a search by function, colour
or gender, or to assemble what they judge to be the
most beautiful things in the Museum's collection.
Any downloaded information (as long as its use doesn't
infringe copyright restrictions) can then be combined
and recombined with material from another source, and
individualised text labels and information panels added
to accompany a bookmarked sequence of curated artefacts.
COMPASS has the potential to turn any desktop monitor
into the agent of a new museological present.

It is clear that rather than just making a physical visit
to the Museum more efficient, this on-line manifestation
may come to constitute the Museum experience for the vast
majority of its 'visitors'. As a result, the narratives threaded
around the images of artefacts will be both sourced from and
influenced by the Museum, but no longer controlled by it. In
response, the Museum is planning to police interpretation
by limiting the number of objects from the collection that
are publicly accessible to just five thousand, as well as by
managing hierarchies of information by tiering it into
'public', 'academic' and 'commercial'. Such a move suggests
that the Museum is unwilling to accept the slide from
sovereign status as a legislator of cultural value, and is
fighting to retain control of its capital. In doing so, it
seems increasingly comfortable using commercial rather
than academic authority.

Selfridges' current website is structured using five
themes: Brands, Stores, Services, About Us and Magazine.
Perhaps it is surprising, given all the media chatter about
the dot.com revolution in retail habits, that the site has

206

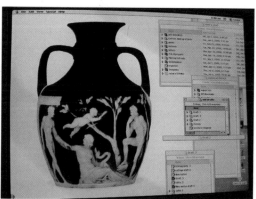

no mechanism for buying goods on-line. It is as if Selfridges
recognises the limitations of the on-screen context, judging
it a space for display and information unable to facilitate a
sensuous exchange between customers and goods. Instead,
the Store is using its website as a portal for the Selfridges
'diffusion' stores, and as a promotional space to entice
the on-line browser into making a physical visit. Users
can search a database of branded goods by clicking on
a diminishing series of multiple options: fashion, men's,
jeans, etc., and eventually the location of a product in the
two current Selfridges stores (in London and Manchester)
appears on the relevant floor map. Browsing the site
reminds the visitor of the looping walkways of the shopfloor
itself, as all the information links lead to the web magazine,
that welcomes your views on its content and design. While
you're sending them, the site registers your details for
future postings of 'features', 'news' and events listings.

This sense of convergence in the practices that will
inform the future digital context of the museum and the
store has implications that permeate beyond the internet.
Leaving behind a period of complacency, department stores
are demonstrating a return to their theatrical beginnings.
For instance, Selfridges looks set to exploit a clear
difference between on-line shopping and a physical visit by
playing up the interactive potential of browsing exhibitions
of goods in-store: to pick things up, try them on, taste
them, and take them home. By returning in this way to the
principle of spectacle that underpinned its early success,
the Store has profited from the recent expansion of the
economy, and has been able to propose an extension to the

London store (to be designed by Norman Foster, whose practice also masterminded the British Museum's Great Court development), and to complement the store in Manchester with a new development in Birmingham. A return to tradition is also evident in the revival of the merchant practices of the departmental buyers. Goods are again being sourced on location the world over, meaning shoppers can be offered a seductively-presented and eclectic mix of products, emphasising another contrast with digital shopping, where there is a certain logic in instantly triggering the restocking of staples through simple clicks of the mouse.

While crucial to the operation of the new store, reservations about the screen interface being a pale substitute for actual contact with things has little relevance to the museum context: in the display case artefacts were always sealed behind glass, always remote. It is perhaps a subtle irony that museums will probably prove more at ease than department stores in the screen-based environment of the world-wide web, as the latter nostalgically retreat back to their exhibitionary roots. The British Museum, despite its certain failure to retain cultural hegemony in a future global economy predicated on knowledge and information, is poised to become a major player via the use of its vast hordes of data to create rich new streams of revenue. To supplement its dwindling public funding, the Museum's commercial arm, The British Museum Company, is keen to exploit this new-found source of digital 'content' value, by creating a tiered licensing structure for access to information on both its collections and its visitors.

210

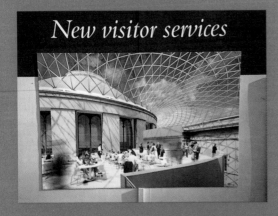

New visitor services

If on closer inspection the differences between
things evaporate, or lie exposed as arbitrary (a worst case
scenario), or ideological (a best case scenario), why do
we persist in misrecognising the structures that make such
distinctions possible? A wilful blindness to the forces at
play in the creation of the value of things has accompanied
the growth of a climate in which market forces have become
the index against which to judge everything. The erosion
of any distinction between the economic and non-economic
precludes the existence of the museum in its 'ideal' form.
A repository of exemplary products, museums were able
to give visible form to the existence of a symbolic economy,
to act as a resistant space outside the system of exchange
involving people and things. They allowed visitors to
experience the social value of the things on display, to feel
the enormous cultural presence of the Elgin Marbles or
the Rosetta Stone, while rendering invisible the enormous
material, political and financial investment required to hold
those objects in place. But now that the guiding prerogatives
of the museum and the store have become so obviously
entangled, their old oppositional relationship retains
only a fraction of its previous force.

In an echo of the swaggering
confidence of its founder, Selfridges
is dreaming up a spectacular building
for its Birmingham site. The computer
models released by the architects,
Future Systems, promise a huge
mound clad in gleaming ceramic disks.

In England, objects that form part
of a museum-stored public collection
literally have no price. Once obtained,
their value isn't estimated as a
capital asset on any cultural audit,
and no valuations are ever divulged
in response to public inquiries.
When objects are given as gifts to
the collection, an estimate of financial
value might accompany them but,
otherwise, only when artefacts are in
transit to other institutions (and this
is very rare) are they given a monetary
value for insurance purposes. This
value is based on the price paid at the
time of acquisition plus appreciation,
or on a best estimate based on the
recent sale of a similar artefact, or on
prices recorded either in auction or
dealers' catalogues.

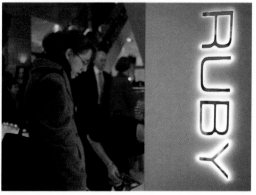

Suggested Further Reading

Collecting

The Collector, John Fowles.
Jonathan Cape, London 1963

*Collectors & Curiosities: Paris
and Venice 1500–1800*,
Krzysztof Pomian.
Polity Press, Cambridge 1990

The Cultures of Collecting,
ed. John Elsner and Roger Cardinal.
Reaktion Books, London 1994

*On Collecting: The European
Tradition*, Susan M Pearce.
Routledge, London 1995

*What It's Worth: the complete guide
to everyday collectables*
Marshall Cavendish, London 1993

Department Store and Shopping

*The Bon Marché: Bourgeois Culture
and the Department Store 1869–1920*,
M B Miller.
Princetown University Press,
New Jersey 1981

'The Department Store as a Cultural
Form', David Chaney. In *Theory,
Culture and Society* 1/3 – 1983

*The Department Store, a social
history*, Bill Lancaster.
Leicester University Press 1995

*The Department Store: its Origins,
Evolutions and Economics*,
H Pasdermajian.
New Man Books, London 1954

Frantz Jourdan and the Samaritaine,
M L Clausen.
E J Brill, Leiden, Holland 1987

*Give the Lady What She Wants: The
Story of Marshall Field & Company*,
Lloyd Wendt and Herman Kogan.
South Bend, Indiana 1952

The Ladies' Paradise, Emile Zola
(trans. Brian Nelson).
Oxford University Press 1995

*Lifestyle Shopping: The Subject of
Consumption*, ed. Rob Shields.
Routledge, London 1992

Retail Trading in Britain 1850–1950,
J B Jeffrey.
Cambridge University Press 1954

The Romance of Commerce,
H Gordon Selfridge.
The Bodley Head, London 1918

Selfridges, Gordon Honeycombe.
Rainbird, London 1984

Shopping With Freud,
Rachel Bowlby.
Routledge, London 1993

Shops and Shopping 1800-1914,
Alison Adburgham.
Allen & Unwin, London 1964

Sister Carrie, Theodore Dreiser.
Penguin, London 1981

*Temptations: Sex, Selling and the
Department Store*, Gail Reekie.
Allen & Unwin, St Leonards, New
South Wales 1993

A Theory of Shopping, Daniel Miller.
Cornell University Press,
New York 1998

*The Universal Provider: A Study of
William Whiteley and the Rise of the
London Department Store*,
R S Lambert.
Harrap, London 1938

*Why We Buy: The Science of
Shopping*, Paco Underhill.
Orion Business Books, London 1999

Economy

The Gift, Marcel Mauss.
Cohen & West, London 1970

*The Order of Things: An Archaeology
of the Human Sciences*,
Michel Foucault.
Tavistock Publications, London 1973

The Philosophy of Money,
Georg Simmel.
Routledge & Kegan Paul,
London 1978

*Symbolic Economies: After Marx
and Freud*, Jean-Joseph Goux.
Cornell University Press,
New York 1990

Symbolic Exchange and Death,
Jean Baudrillard.
Sage Publications, London 1993

'The Work of Art in the Age of
Mechanical Reproduction',
Walter Benjamin.
in *Illuminations,* Schocken Books,
New York 1969

General History

*The Age of Empire 1875–1914/The Age
of Capital 1848–1875*,
Eric Hobsbawm.
Weidenfeld & Nicholson,
London *1987/1997*

*The Birth of Consumer Society:
The Commercialization of
Eighteenth-Century England*,
ed. Neil McKendrick, John Brewer
and J H Plumb.
Europa, London 1982

*Civilization and Capital: Volume II,
The Wheels of Commerce*,
Fernand Braudel.
Fontana, London 1985

The Romantic Ethic and the Spirit of Modern Consumption,
Colin Campbell.
Blackwell, Oxford 1987

Material Culture

The Accursed Share: Volume I,
Georges Bataille.
Zone Books, New York 1991

Bricobracomania,
Remy G Saisselin.
Thames & Hudson, London 1985

The Dialectics of Seeing: Walter Benjamin and the Arcades Project,
Susan Buck-Morss.
MIT, Cambridge, Mass. 1989

Distinction: a Social Critique of the Judgement of Taste,
Pierre Bourdieu.
Routledge, London 1984

Dream Worlds: Mass Consumption and Late 19th-Century France,
Rosalind Williams.
University of California Press 1982

The Evolution of Useful Things,
Henry Petroski.
Vintage Books, New York 1994

Material Culture and Mass Consumption, Daniel Miller.
Blackwell, Oxford 1987

Objects of Desire, Adrian Fortis.
Thames & Hudson, London 1992

On Longing: Narratives of the Miniature, the Gigantic, the Souvenir and the Collection, Susan Stewart.
Duke University Press, Durham, North Carolina 1993

The Practice of Everyday Life,
Michel de Certeau.
University of California Press, 1984

The Predicament of Culture,
James Clifford.
Harvard University Press, Cambridge, Mass 1988

The Social Life of Things,
ed. Arjun Appadurai.
Cambridge University Press 1988

The System of Objects,
Jean Baudrillard.
Verso, London 1996

The Theory of the Leisure Class,
Thorsten Veblen.
Dover Publications, New York 1994

Things, George Perec.
Harvill, London 1991

World of Goods,
Mary Douglas and Baron Isherwood.
Basic Books, New York 1979

Museum

The Birth of the Museum,
Tony Bennett.
Routledge, London 1995

The British Museum,
J Mordaunt Crook.
Penguin Books, London 1972

Building the British Museum,
Marjorie Caygill and
Christopher Date.
British Museum Press, London 1999

Civilizing Rituals: Inside the Public Art Museum, Carol Duncan.
Routledge, London 1995

The Collections of the British Museum, ed. David M Wilson.
British Museum Press, London 1989

For the Love of Art: European Museums and their Public,
Pierre Bourdieu and Alain Darbel.
Polity Press, Cambridge 1991

The Museum Age, Germain Bazin.
Universe Books, New York 1967

Museum Memories: History, Technology, Art, Didier Maleuvre.
Stanford University Press, California 1999

On the Museums Ruin,
Douglas Crimp and Louise Lawler.
MIT, Cambridge, Mass. 1993

Visual Culture

Beyond Recognition: Representation, Power and Culture, Craig Owens.
University of California Press 1994

Commerce and Culture,
ed. Stephen Bayley.
Design Museum, London 1989

The Culture of the Copy,
Hillel Schwartz.
Zone Books, New York 1995

Ephemeral Vistas: A History of the Exposition Universelles, Great Exhibitions and World Fairs 1851–1939, Paul Greenhalgh.
Manchester University Press 1988

'Exposition Universelle 1855',
Charles Baudelaire
in *Art in Paris 1845–62*.
Phaidon, London 1965

'Paris, Capital of the Nineteenth Century', Walter Benjamin.
in *Reflections*. Harvest, NY 1978

The Power of Display: a History of Exhibition Installations at the Museum of Modern Art,
Mary Anne Staniszewski.
MIT, Cambridge, Mass. 1998

The Return of the Real, Hal Foster.
October Books, MIT, Cambridge, Mass. 1996

Thinking About Exhibitions:
ed. Reesa Greenberg,
Bruce W Ferguson and
Sandy Nairne.
Routledge, London 1996

Visual Display: Culture Beyond Appearances, ed. Lynne Cooke and Peter Wollen.
Bay Press, Seattle 1995

Index